Watercolor Journeys

Create your own travel sketchbook

WATERCOLOR
Journeys

Create your own travel sketchbook

Richard Schilling

NORTH LIGHT BOOKS
CINCINNATI, OHIO
www.artistsnetwork.com

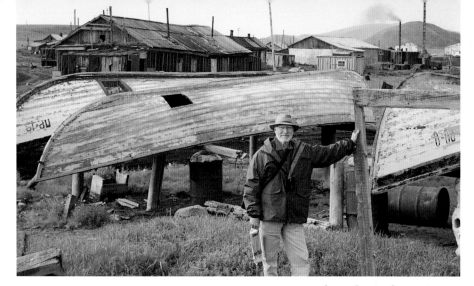

The author in the Arctic
fishing village of Nunligran,
Russia.

Richard Schilling's love affair with watercolor began in the sixth grade when he was chosen to receive art instruction at the University of Nebraska on Saturday mornings.

Schilling is an instructor of both watercolor and clinical dentistry. In addition, he and his wife, Marlene, work for Holland America Line as part-time cruise ship's dentist and assistant. They have also served as dental missionaries in developing countries. The author says that he enjoys helping others discover a manner in which to record their own life's experiences.

Schilling has contributed articles to **The Rotarian, American Artist, The Artist's Magazine** and **Worldwide Challenge Magazine**. His work has been showcased in **Southwest Art, Rosebud** and **Lake Superior** magazines and has also appeared in the following books: **The Island Within Us** (Isle Royale Natural History Association), **The Kalenjiin Heritage** (William Carey Library) and **Contemporary Western Artists** (Bonanza Books).

In 1996 he was selected as Artist-in-Residence at Isle Royale National Park and was part of the Arts for the Parks' national traveling exhibition for 1997-98.

Watercolor Journeys: Create Your Own Travel Sketchbook. Copyright © 2003 by Richard Schilling. Manufactured in China. All rights reserved. No part of this book may be reproduced in any form or by any electronic or mechanical means including information storage and retrieval systems without permission in writing from the publisher, except by a reviewer who may quote brief passages in a review. Published by North Light Books, an imprint of F&W Publications, Inc., 4700 East Galbraith Road, Cincinnati, Ohio, 45236. (800) 289-0963. First Edition.

Other fine North Light Books are available from your local bookstore, art supply store or direct from the publisher.

07 06 05 04 03 5 4 3 2 1

Library of Congress Cataloging in Publication Data

Schilling, Richard
 Watercolor journeys : create your own travel sketchbook / Richard Schilling.— 1st ed.
 p. cm
 Includes index.
 ISBN 1-58180-272-2 (hc. : alk. paper)
 1. Travel in art 2. Watercolor painting—Technique. 3. Notebooks. I. Title.

ND2365 .S35 2004
751.42'2—dc21 2002033742

Edited by James A. Markle
Designed by Wendy Dunning
Production art by Christine Long
Production coordinated by Mark Griffin

Metric Conversion Chart

To convert	to	multiply by
Inches	Centimeters	2.54
Centimeters	Inches	0.4
Feet	Centimeters	30.5
Centimeters	Feet	0.03
Yards	Meters	0.9
Meters	Yards	1.1
Sq. Inches	Sq. Centimeters	6.45
Sq. Centimeters	Sq. Inches	0.16
Sq. Feet	Sq. Meters	0.09
Sq. Meters	Sq. Feet	10.8
Sq. Yards	Sq. Meters	0.8
Sq. Meters	Sq. Yards	1.2
Pounds	Kilograms	0.45
Kilograms	Pounds	2.2
Ounces	Grams	28.4
Grams	Ounces	0.04

ACKNOWLEDGMENTS

"I have gathered a posie of other men's flowers, and
nothing but the thread that binds them is mine own."

—John Bartlett

I am indebted to many men and women who have provided the flowers of my life. I have tried to bind their influences together into an attractive arrangement that would honor their investment in me. I am humbled as I think of these individuals and the inexplicable events that have shaped my life and career. Most importantly, I want to thank my parents, who guided and nurtured my development with love and wisdom.

Darrell "Skip" Elliott was an early, motivating teacher, who had the gift of infecting others with his contagious enthusiasm for watercolor.

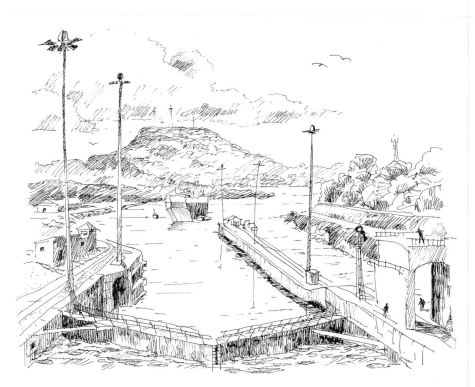

I thank those who read the original manuscript of the **African Journal**, a predecessor to **Watercolor Journeys**, for their encouragement. Especially Ted Schmidt, director of the Loveland Colorado Library, who provided constant encouragement to publish my work.

I am indebted to authors Gerald and Burnett Fish for reading my original manuscript and giving me a desire to learn the religious practices and culture of the Kalenjiin people of Africa.

I owe my appreciation to Daniel arap Salat, Africa Gospel Church pastor and retired schoolmaster, and his own childhood schoolmaster, Henry arap Tuei. They taught me the traditions of their culture, some of which were unknown to their own people.

I wish to thank Dr. Magdalena Jaszczak for her gift of poetry and for permission to share the innermost feelings from her heart.

Holland America Line, World Medical Mission, Samaritan's Purse and Rotary International provided opportunities for me to travel and practice my primary profession, dentistry, on board ships at sea and as a volunteer dentist in developing countries. These experiences enriched my life and provided great subjects to paint.

Still, this book would not have happened if it were not for Rachel Wolf, acquisitions editor of North Light Books, who caught my vision for the project. Thank you, Rachel, for having faith in me.

Robert Heiser provided invaluable advice for photographing images of the sketchbook for publication.

Finally, it all came together thanks to my gifted editor, Jamie Markle. He guided me through the maze of preparation with skill, patience and sensitivity to the concept that I envisioned for the book and has remained, throughout this arduous process, my friend.

*To Marlene, who signed on some years ago as
co-captain of this journey of discovery. My joy
has been in the journey, and without her life
would have been just a business trip.*

I might be called a watercolor evangelist, for I have a missionary zeal to help others discover the joy of watercolor painting and sketchbook journaling. It's difficult to say when my journey began, as I cannot remember a time in my life when I did not draw pictures. The pursuit of beautiful things and a consuming interest in discovering life are inextricably knitted in my very being.

As a child I wanted to make things—cars and airplanes fashioned from bits and scraps found under my father's workbench or wooden boats that I launched in the street gutter in the rushing water following a summer rain. My drawings, like those of most boys during wartime, were of dive-bombing fighter planes and tanks spewing shells and bullets

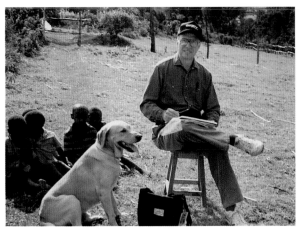

The author with some of his young friends.

upon the Axis enemy. My mother sensed a spark of talent in all of this and guided me in a less violent direction. She bought me a set of oil paints; my first painting was of a boat dock at Yellowstone Lake. It was done completely from memory. If there was to be a starting point in my career, this must have been it. I was hooked!

In my hometown of Lincoln, Nebraska, I was sheltered from the frightening events of war taking place elsewhere in the world. I liked school and art became my favorite class.

Nearing my tenth birthday I asked for one of two things: my own microscope or a beautiful book entitled **World-Famous Paintings**, edited by Rockwell Kent. My father chose to give me the book, inscribing it "to use as your 'microscope' to learn more about art." It was the beginning of my collection of art books that I continue to enjoy and use as reference.

I was twelve years old when I began taking classes on Saturday mornings at the art department at the University of Nebraska. The upper floors of our building contained the university's permanent collection of art as well as classrooms; thus, I discovered the joy and excitement of an art museum at an early age.

I graduated from the University of Nebraska's College of Dentistry. I chose dentistry for my livelihood, but the pursuit of art was a constant travel companion.

In 1993, I began traveling to several developing countries as a volunteer dentist. Painting was both a means of chronicling my experiences and a defense against loneliness. I made two trips to Kenya, where I worked in a remote hospital far from the typical tourist sites. I had an extraordinary opportunity to paint the African scene and culture.

On three occasions I traveled to Siberia to treat the indigenous peoples in remote villages who had no access to dental care. During these long months, I found comfort and solace in sketching my surroundings. In Honduras, the hot and dusty villages were wonderful to paint. Sketching was a welcome respite from the intense and exhausting work of treating, seemingly, endless lines of waiting villagers.

Amazingly, dentistry provided other opportunities for me. In 1996 I became a part-time dentist for Holland America Line, providing dental care for the crews of the company's ships. I took my responsibility of providing care for the Asian crew seriously, but when in port, I pursued my passion of painting the local scenes in various sketchbooks.

After several years of sailing I have filled many books with sketches and paintings from Alaska, Mexico, Central and South America, Europe, Africa and Russia. It is my pleasure to share some of these memories with you. I hope you enjoy them and that my sketchbook adventures continue for many years.

Table of Contents

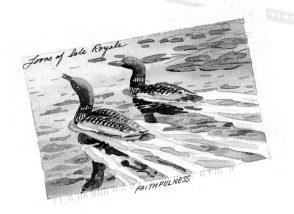

Introduction: Why Keep a
 Sketchbook Journal? 10

Packing Your Bags 14

Simplicity! That's Your Ticket 16

Choosing Your Location 18

Adventures in Format 20

Taking Off: Beginning Your Painting 22

What's Your Point of View? 24

Traveling With Style 26

Drawing on Experience:
 Creating Pen and Ink Sketches 28

Shifting Shadows 30

Painting the Town 32

DEMONSTRATION
 San Marco Piazza: Painting With
 a Photo Reference 34

Seeing Double 36

Designing Ways 38

DEMONSTRATION
 Damage Control: Lifting Paint 40

Getting Your Full Value 42

DEMONSTRATION
 The Old Granary: Making
 Value Sketches 44

Improving Your Image: Rules for
 Reflected Images 46

Take Ten! The Ten-Minute Sketch 48

Help! It's Starting to Rain 50

DEMONSTRATION
 After the Storm: Capturing Emotion 52

Remarque-able Paintings:
 Pencil With Watercolor 54

Going the Distance: Creating
 Depth in Pictures 56

DEMONSTRATION
 Creating Depth in Landscapes 58

Faces in a Crowd 60

Covering the Territory:
 Title Pages and Covers 62

Plants and Flowers 64

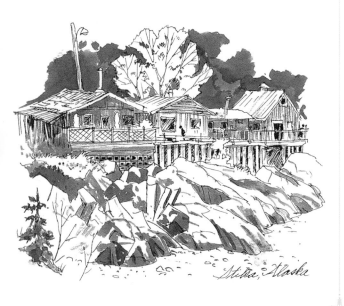

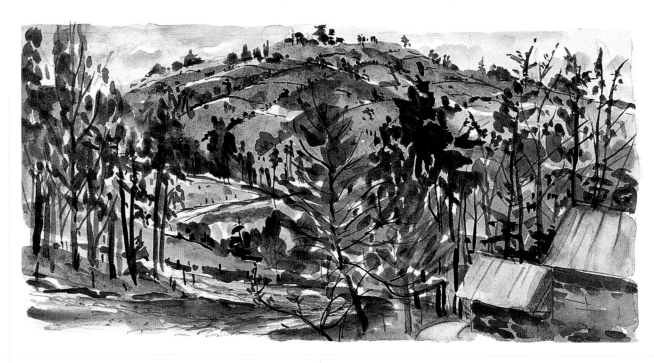

DEMONSTRATION
Poppies in Vail: Painting Alla Prima 66

Home Is Where the Heart Is 68

Welcome Home: Friendships
and Dinner Invitations 70

DEMONSTRATION
Woodworking: Painting Wood 72

Unfriendly Receptions 74

Ambassador With Portfolio
(Art, That Is) 76

Friendly Encounters 78

A Visit to My Hometown 80

Artistic License 82

Capturing Life 84

People at Work 86

Calling All Ships at Sea! 88

A Walk in the Park 90

People Pleasers: Suitable Models 92

Pretty Cool Places 94

DEMONSTRATION
Painting Rocks: Creating Form 96

Mapping the World 98

Painting at Historic Sites 100

DEMONSTRATION
The Grand Canal of Venice: Painting
Weathered Buildings 102

Natural Disasters and Other
Environmental Annoyances 104

Discovering Customs and Cultures 106

The Bridge of Life 108

Wish You Were Here: Postcards
to Friends and Family 110

Nature and Animals 112

Poetic License 114

Paintings From the Ends of the Earth 116

The Root Cause 118

The Panama Canal: A Visual Journey 120

Through the Canal: Setting Your Course 122

Saying Goodbye 124

Index 126

Twenty years ago I discovered a book that proved to have a tremendous impact on my work and my art career. The book was actually a published reproduction of a sketchbook entitled **Muriel Foster's Fishing Diary**. Muriel Foster was a spinster who was born in the village of Shenley in Surrey, England about one hundred years ago. She had a lifelong passion for both painting and fly-fishing. Foster's family was among the privileged class, which freed her for the pursuit of art and fly-fishing, two activities that are synonymous in my way of thinking.

Foster filled her long and narrow log with amazing pieces of information and charming watercolors illustrating each adventure. The book contains meticulous detail and data along with pictures of colorful fly patterns and the fish she lured. She illustrated the birds and animals encountered on each outing as well as the lochs and rivers where she fished. Nothing seemed to escape her eye for discovery.

One of the last entries in her fishing journal was this crusty note… "Finis, Arthritis!" Foster passed away in 1963 after living a long and productive life.

After reading Foster's work, I wanted to learn more about other artists and explorers who used sketchbooks to illustrate and document their observations. I tried to imagine a world without photographs or video cameras. People had to depend on their own drawing and painting skills to record life.

I gained many insights about the history of the art of sketchbooking. In England, painting was an important part of one's education. For the upper class who were freed from labor, painting was an important pastime. Others developed it as a profession, for there was always a demand for their services. The wealthy traveled with artists who performed their work much like photographers today. A family might visit distant lands and return with an artist's paintings to decorate their home and show their friends.

Lewis Miller recorded life—the genre and the history—in a most remarkable manner. Like Muriel Foster, Miller never married. This freedom from family obligations may explain his ability to create an impressive volume of sketches of rural Pennsylvania and Virginia. Most likely Miller began sketching for his own enjoyment but as his fame grew, he became known as a chronicler of local events and happenings. Miller had an insatiable curiosity for life. Thousands of his drawings exist today as important pictures of life in the nineteenth century.

Prior to the nineteenth century, botanists and explorers had to rely on their artistic renderings to record scientific discoveries. Many of them were quite good at it. Women represented one-half of all botanists in the late nineteenth century. Maria Martin painted some of the backgrounds for paintings by Audubon, and Graceanna Lewis wrote and illustrated **A Natural History of Birds** in 1844.

President Thomas Jefferson commissioned an expedition led by Meriwether Lewis and William Clark to explore the Louisiana Purchase and return with maps and descriptions of all they saw. Both men recorded their findings in field diaries and collected many specimens that were sent back to be studied.

Explorer John Muir recorded his adventures in Alaska and California while artists Alfred Bierstadt and Thomas Moran were instrumental in showing the magnificent grandeur of the American West. Thomas Moran was captivated by the magnificent and surreal landscape of northwest Wyoming. His beautiful paintings served as powerful testimony before the United States Congress and were largely responsible for the establishment of our first national park. The land had captured Moran's heart and spirit, and from that time forward he signed his paintings, Thomas "Yellowstone" Moran.

As you can see, as artists we belong to a large fraternity. We can identify with the explorers, the pathfinders and the early artists along with those who possess inquiring minds and observing eyes. To paint is to understand.

You don't have to be a full-time artist to be professional in this pursuit. Your attitude and approach to painting will determine professionalism. It does

not mean that you are less professional because you do not make your livelihood from creating art. Nor must you be an experienced artist, or a world traveler, to enjoy making pictures. A visit to a nearby park or flower garden can provide endless subjects and hours of painting enjoyment. Maybe you have not even considered yourself an artist. Yet you may find that sketchbooking will help you "see" in a very new and discerning way. Besides, it is just plain fun.

I hope this book will be an encouragement to you. Not only will you find instructional material in this sketchbook, but I hope to help you develop a passion for creating pictures about your life. There are many excellent instructional books available that can teach technique. I would like to encourage you to just do it. Your style is your personality. Lewis Miller's work may have been considered primitive, but it demonstrated freshness and an innocence that was free of outside influence. Let your own personality show in your sketches. Throw off the constraining rules of convention and technique and release the creative power that is uniquely yours. I hope this book will persuade you to begin your own watercolor journey.

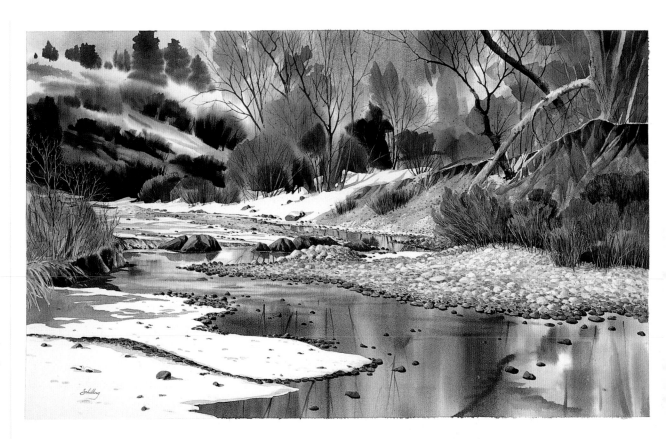

"I prefer every time a picture composed and painted outdoors," he said. "This making studies and then taking them home to finish is only half right... you lose freshness; miss the subtle... finer characteristics of the scene."

—Winslow Homer

Packing Your Bags

Deciding what to put in your painting bag may be just as personal as what clothing to take on your next journey. I am an advocate of simplicity for both. Make an inventory of the supplies you commonly use and compare it with my list.

Don't burden yourself with more than you realistically expect to use. Sometimes I customize my bag for a specific trip. I take larger scale supplies for larger, more serious paintings and throw them in my shoulder bag with everything else.

If I'm traveling with friends and don't wish to slow their sightseeing, I carry a mini-sketchbook, a tiny box of six watercolor pigments and a sketching pen. I also take a small pill bottle filled with water and a collapsible brush. All of these things fit conveniently in a camera case. If you simply want to sketch, slip a 4" x 5" (10cm x 13cm) sketchbook, pen and a couple of markers into a ziplock bag and store them in your shirt pocket.

SELECTING A CASE

When purchasing a carrying case, I suggest you lay out all your supplies and measure the size and volume of space they require. Take your measurements to a store that stocks a large supply of camera bags and select one that suits your needs. Of course, carrying bags are available in art stores and catalogs, but the wide variety of camera and video cases offers more customized options.

PAINTS

It is best to use the highest grade of all materials. I like Winsor & Newton, Schmincke and Holbein watercolors. I own travel-sized paint-boxes containing pan pigments from each of these companies. Most travel-sized paint boxes have a good assortment of pigments.

PAPER

Heavy grade, acid-free watercolor paper will accept washes well and remain unwrinkled when dry. Michael Roger Press, Inc. makes excellent watercolor books in a variety of sizes and styles. The books are wire bound, allowing them to open completely and lay flat on a hard surface. The paper is 140-lb. (300gsm) cold-pressed, which provides a nice surface for all paintings. The front and back of each page has a slightly different texture, which gives you the option to select the surface that best compliments your subject and technique.

BRUSHES

Convertible brushes that can be separated and stored conveniently inside their handles are marvelous inventions. Improper or accidental handling can ruin conventional brushes. It is not important to have a wide assortment of brushes. I have found that the Da Vinci no. 8, series 1503 brush can be used almost universally. Occasionally, I will use a no. 10 for pictures requiring larger washes. Whatever brand you use, make sure your brushes are made of high-quality sable hair shaped to very fine points. They should function well for both fluid washes and the demands of exacting detail.

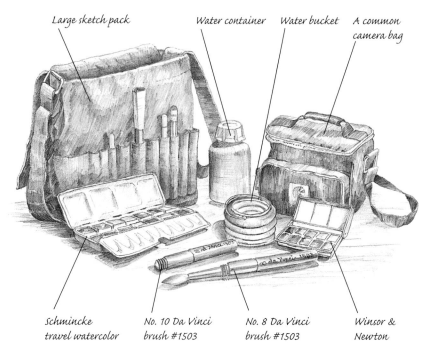

Large sketch pack Water container Water bucket A common camera bag

Schmincke travel watercolor paint box No. 10 Da Vinci brush #1503 (folded) No. 8 Da Vinci brush #1503 (opened) Winsor & Newton paint box

Two Ways to Pack Your Bags

My large sketch pack is used for larger work produced on location. It holds a 9" x 12" (23cm x 30cm) sketchbook, a paint box, a bottle of water, extra brushes, plastic bags and a paint rag.

The smaller pack is perfect for impromptu sketching. It holds a 5" x 7" (13cm x 18cm) sketchbook, a small Winsor & Newton paint box, folding brushes, paint rags and sometimes a small camera.

The S. S. *Rotterdam* in Juneau, Alaska

As dental officer aboard ship I am required to take part in all training and safety exercises with the crew. Today we tested the sea-worthiness of the lifeboats. Waving good-bye to my wife, I was lowered to the sea with a dozen fellow sailors. The view of my beautiful ship from a bobbing lifeboat was neither the perspective nor the subject I cared to paint.

My sense of security waned along with the view of my vessel that was slowly shrinking in size in the distance. I don't know the difference between a bowline and a bosom's mate, but I knew something was seriously wrong when water began to fill the bottom of the lifeboat and reached my ankles. The coxswain ordered us to row, but the mechanical rowing apparatus had locked up and was useless—we were dead in the water.

Thankfully, we were not required to test the seaworthiness of the life jackets, for we were soon rescued by a power launch and towed unceremoniously to our ship amid the laughter of the waiting crew.

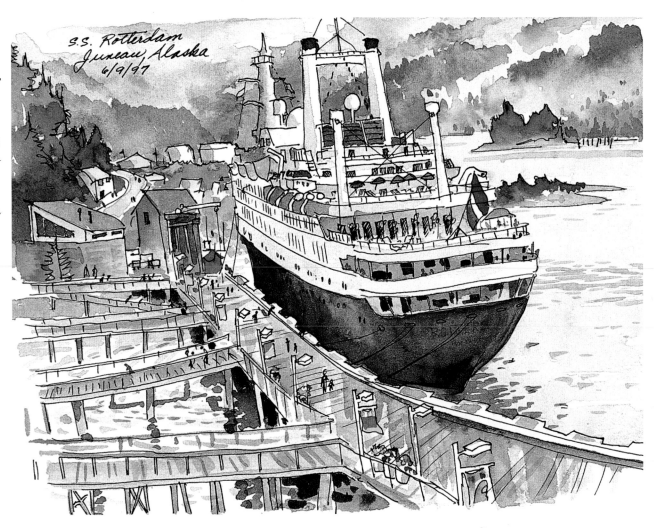

S.S. Rotterdam
Juneau, Alaska
6/9/97

JOURNAL NOTE

Painting Survival Kit

Necessities

No. 8 sable brush · Travel box of watercolor paint
Watercolor book · Several pencils and kneaded eraser
Sketching pen with permanent black ink · Small cloth towel
Two heavy-duty paper clips
Small package of tissue for cleanup · Small pencil sharpener

Accessories

Light- and medium-gray watercolor markers
Watercolor pencils · Block of blank watercolor postcards
Piece of white chalk or Conté crayon · Fingerless gloves
Small bottle of ink for washes

Simplicity! That's Your Ticket

"Try to reduce everything you see to the utmost simplicity. That is, let nothing but the things which are of the utmost importance to you have any place. The more simply you see, the more simply you will render."

—Robert Henri, *The Art Spirit*

I preach simplicity to myself every time I begin a painting. An otherwise good painting can be lost by the inclusion of too much extraneous detail that distracts from the central idea.

I study my subject for a few important moments before beginning a sketch. I ask myself, "What is important about the scene? What things should I leave out in order to improve the design?" At times, there is a fine distinction between unimportant detail and **action lines**. Action lines are linear elements that can be vertical, horizontal or diagonal. Telephone posts, streets, fences and power lines are examples of objects that can be used to direct the viewer's eye into the picture. Trivia complicates the artistic message, while action lines add excitement to the subject.

A sketch should capture the overall impression of a subject—there is no time for accuracy. Your painting is an artistic interpretation and not an architectural rendering. Pictures, like the spoken word, are often more effective when condensed to their essential elements.

The Biltmore Estate—A Complicated Subject
I reduced this mammoth structure to its most simplified form. It's a rare occurrence when I find a comfortable position from which to work. Today I had no option but to stand and sketch.

A Break in Puerto de la Coruna, Spain
Fishing boats came and left during this thirty-minute sketch. These are only a couple boats and my impression of the buildings that circled the harbor.

16

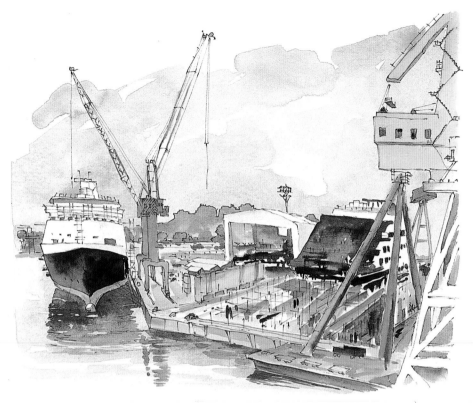

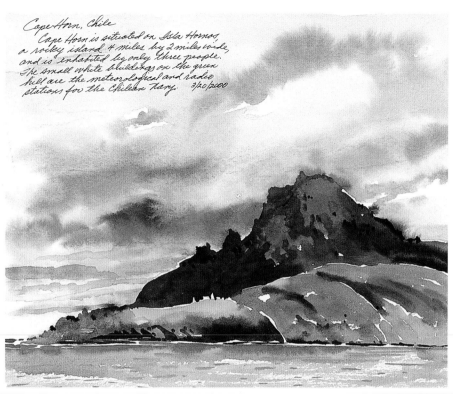

Cape Horn, Chile
Cape Horn is situated on Isla Hornos,
a rocky island 4 miles by 2 miles wide,
and is inhabited by only three people.
The small white buildings on the green
hill are the meteorological and radio
stations for the Chilean Navy. 3/20/2000

ACTION LINES IN VENICE, ITALY

There was a lot of energy and activity going on in this shipyard. Notice the number of action lines created by the dock, buildings and booms. The combination of horizontal, vertical and angular lines recreates that same feeling of energy.

CAPE HORN, CHILE

PAINTING FROM MEMORY

A motorboat and guide took me to the amazing Los Arcos de Cabo San Lucas where the Baja California peninsula disintegrates into the sea. Painting this picture from a pitching boat was impossible, so I used my memory. I made a photograph-like image in my mind and painted it after returning to the dock. This technique simplifies a subject and focuses on the essentials of the composition.

17

Choosing Your Location

Finding the perfect spot from which to create a picture is nearly impossible. The perfect location may be in the middle of a busy intersection. In this case, there are only two options: either I make my sketch from the closest position or I imagine how my subject would appear from a different perspective.

Safety and a sense of security are the foremost considerations. I try to position myself with my back to a wall or permanent structure. Other favorite locations are building entrances, stoops, the tops of stone walls and park benches. I feel safe in these places.

Remember that situations can change without warning. I have painted in congested industrial areas and felt safe until workmen have, on occasion, started dangerous equipment nearby. It is easy to become preoccupied with work and be unaware of danger.

Choosing a location also involves being aware of the position of the sun. I prefer an unchanging, shady spot. A completely sunny location is also good. But the intermittent shade and sunlight beneath a leafy tree can drive an artist to madness.

After I finally choose my subject and locate a safe place from which to paint, I decide how much time I wish to invest. Time restraints are helpful because they prevent me from belaboring a work and becoming caught up with insignificant detail.

One final tip: Be sure to look around your location before beginning. While working in Africa I learned that my painting enjoyment was inversely proportional to the number of ants I was sitting on.

AN AERIAL VIEW
The *Crows Nest Lounge* in the bow of my ship provided this unique view of the busy harbor. Aerial views, if you can find them, often present interesting perspectives on buildings and landscapes.

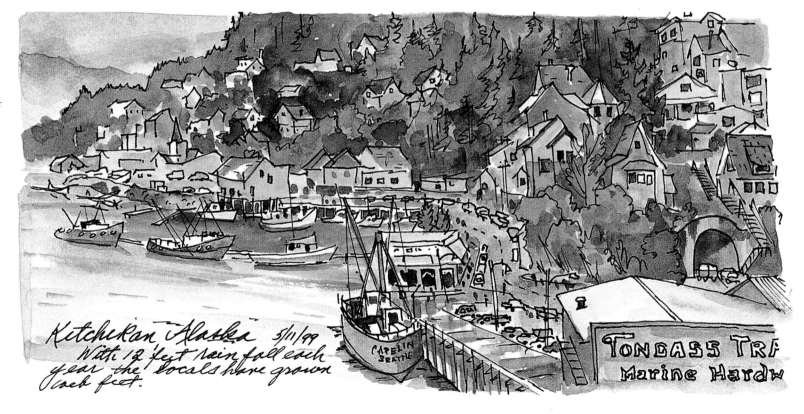

Ketchikan Alaska 5/11/99
With 12 feet rain fall each
year the locals have grown
web feet.

CAPELIN
SEATTLE

TONGASS TRA
Marine Hardw

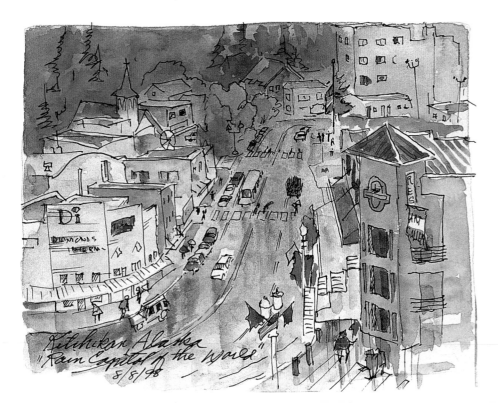

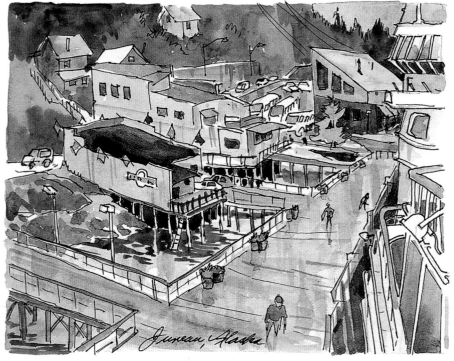

A Shipboard Vista in Ketchikan, Alaska

My ship made a port call at Ketchikan on this rainy day, which is too miserable to work outdoors. On the top deck of the ship I found the perfect view of this busy main street. Shipboard vistas are perfect because the elevation provides an interesting perspective of all you survey.

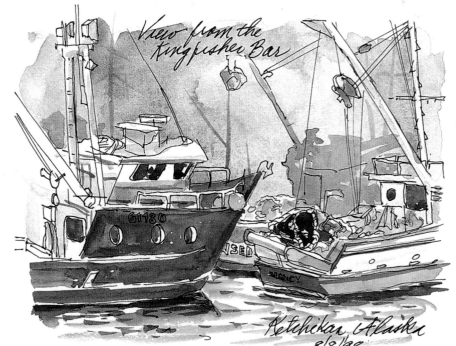

Rainy Morning in Juneau, Alaska

My eye is always open for a different perspective on my subject. This high-angle view is much more interesting than viewing the town from ground level.

A Dry Spot on a Rainy Day

Finding a vantage point for a sketch on this rainy day in Ketchikan, Alaska was difficult. I finally found a tavern with a window next to some fishing boats. My only concern is to watch my tendency to dip my brush in my beer rather than my water glass.

19

Adventures in Format

I like to use watercolor sketchbooks of different proportions. Some are half filled with pictures, waiting to have more paintings of a similar format or subject added. Most of my work fits best into a horizontal format, but there are differently proportioned, horizontal watercolor books available. Where and what I will be painting dictates which book I take along. For broad subjects and wide landscapes, the long, narrow books are perfect. Some subjects, such as portraits, may lend themselves better to a vertical page.

JOURNAL NOTE

Selecting a Sketchbook

Here are a few of my favorite book shapes and sizes (the first number is the vertical dimension):

Vertical format:

12" x 9" (30cm x 23cm)

Horizontal format:

4" x 9" (10cm x 23cm)

5" x 7" (13cm x 18cm)

7" x 10" (18cm x 25cm)

9" x 12" (23cm x 30cm)

11" x 14" (28cm x 36cm)

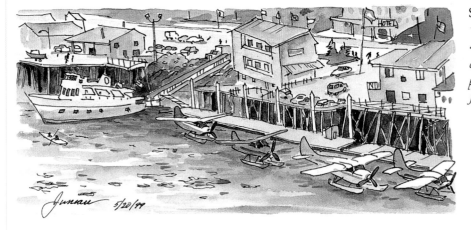

Juneau 5/20/99

SKETCHING YOUR VIEW

This horizontal format in my 4" x 9" (10cm x 23cm) watercolor book is perfect for this painting of the city dock in Juneau, Alaska.

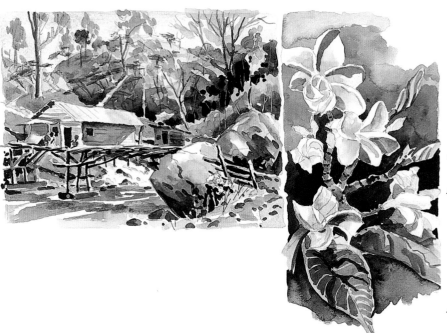

SCENES OF AFRICA

Two different subjects share the same page of this African diary. This is a grist mill on the Nyangores river. The path down the hill is a busy thoroughfare. Many children crowded around to watch me paint. When I finished, they laughed with much glee as I folded up my accordion-style water container.

Emmanuel crawled into the Frangipani tree to pick this blossom for me to paint. When the branch is broken, large amounts of latex seep from the break. The name originates from a perfume developed from its flowers by a twelfth century nobleman of the same name.

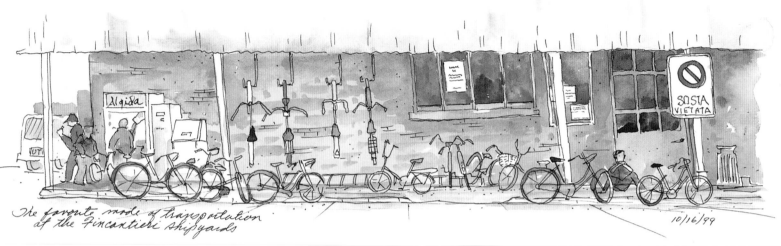

The favorite mode of transportation at the Fincantieri shipyards

10/16/99

Venice 10/15/99

VENETIAN LIFE

I placed two horizontal sketches on the same page as a change of pace from the usual full-page format. For several weeks I worked in a shipyard in Venice, Italy. I ate my sack lunch while sitting on construction supplies. I used my remaining time to record activities that were taking place around me. The sights were not always pretty, but they were usually interesting. The workers' bicycles created a good design for the top picture.

The Venice panorama (bottom image) was drawn in pen and ink. I began the drawing by producing an outline of distant buildings. This provided an orientation and set the size standard for the rest of the drawing. I worked from the more distant buildings forward and developed the city portrait.

21

Taking Off: Beginning Your Painting

Beginning a painting can be as confusing as making travel arrangements. After you choose the best vantage point for your picture, it is time to sit down and spend a couple of minutes studying the scene. This is time well spent. Not only must you decide what extraneous visual clutter to leave out; you must also decide where to begin your drawing. This is most important when pen and ink is used.

Don't paint yourself into a corner by not allowing for the larger objects in the foreground. I sketch working from the foreground to the background, identifying the larger objects or people in the foreground. These shapes become the standard for size comparison to more distant objects. I then draw the images in the middle ground and background.

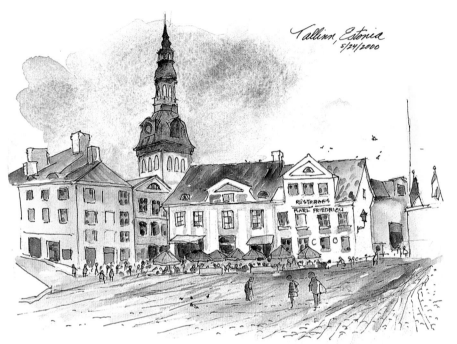

Tallinn, Estonia
5/24/2000

TALLINN, ESTONIA
I was warmed by a hot cup of cappuccino as I watched the city come alive on a chilly autumn morning. I began this picture using my rollerball pen to locate and define the buildings. Simple stick-figure drawings indicate the presence of people. The sketch was rapidly brought to completion with some splashes of color.

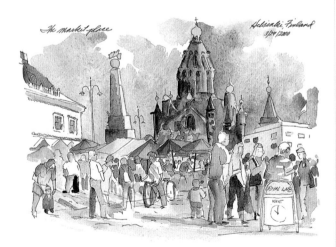

The market place *Helsinki, Finland*
3/29/2000

FOREGROUND FIRST
I began drawing the foreground of this outdoor market in Helsinki, placing the shapes of people and tents before describing the more distant churches and monuments. I most often begin paintings this way to establish the more important items in the painting.

BREAKING THE RULES, MESSINA, SICILY
Rules are for breaking. Here I reversed my technique by sketching the skyline first. This gave me landmarks for the placement of the Italian buildings and rooftops. I used pen and ink to develop the picture, working from top to bottom. There were no large shapes in the foreground of this city panorama.

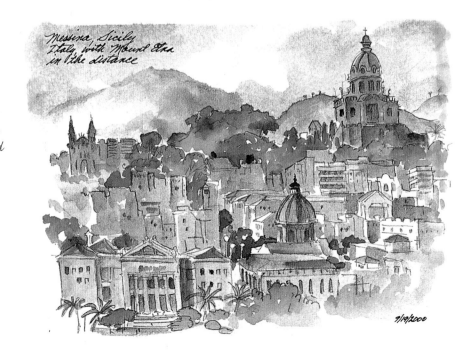

Messina, Sicily Italy with Mount Etna in the distance

7/19/2000

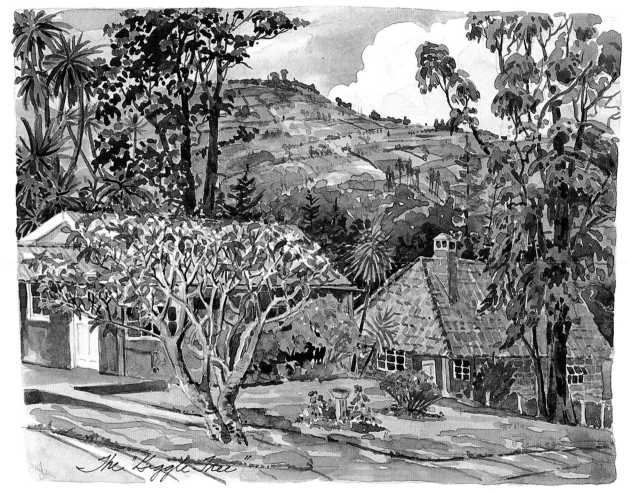

The "Giggle Tree"

THE PAINTING SEQUENCE

With so much going on in this scene it was important to have an idea of the sequence for the development of the picture before I started. With pencil, I blocked in the objects, starting with the frangipani tree in front, then progressed through the middle ground and on to the distant hills of the background. I then painted the image in the same order: foreground, middle ground and background.

JOURNAL NOTE

The Giggle Tree

The frangipani tree, at Tenwek Hospital, is called the GIGGLE TREE. *The joyous laughter that emanates from the branches of the tree has caused the children who climb it to be known as the* FRUIT *of the giggle tree.*

It is a perfect tree for climbing. The base the tree divides quickly into thick but stubby branches, allowing even small children to navigate the maze of vegetation.

Even the giggle tree gives up its fruit, which sometimes falls to the ground. On his birthday, three-year-old Bryant and his friends were climbing the giggle tree. Bryant fell, displacing two of his front teeth. His father brought his unhappy son to the dental clinic where I moved the teeth back into position. I prescribed unlimited application of ice cream and cake to the affected area.

As I passed his cottage on my way home that evening, Bryant ran to greet me. His smile assured me he was well on his way to a complete recovery.

What's Your Point of View?

I look for unusual perspectives when selecting locations for my paintings. This involves **seeing** in a new way and looking for subjects that are less obvious or commonplace. Sometimes my subjects are literally underfoot; leaves, flowers, berries and even twisted tree roots provide interesting subjects. At other times my viewpoint will be far away, providing more of a bird's-eye view.

Observe your subject from different angles. See if it can be sketched from a lower or higher elevation than the usual eye-level perspective.

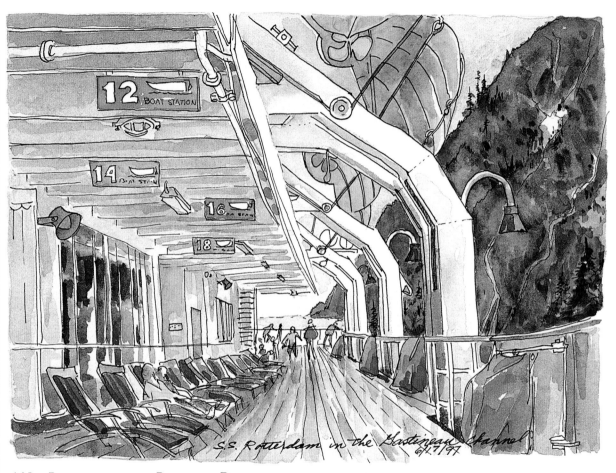

A New Perspective of the Promenade Deck
This good look at the lifeboats from below shows depth and perspective from a traditional, eye-level position. Selecting a unique point of view can give you some interesting perspectives in your paintings.

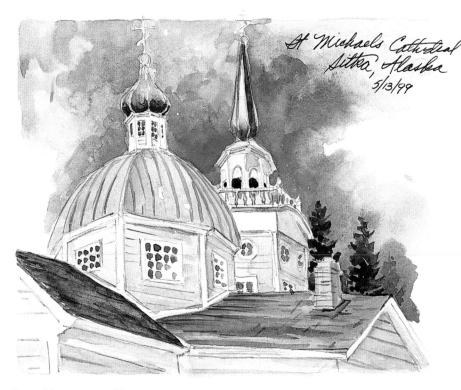

St. Michaels Cathedral
Sitka, Alaska
5/13/99

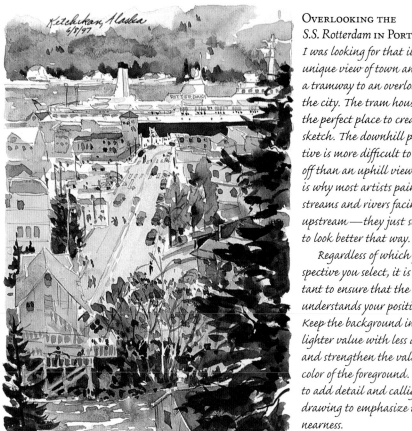

Ketchikan, Alaska
6/8/97

OVERLOOKING THE S.S. ROTTERDAM IN PORT

I was looking for that illusive, unique view of town and took a tramway to an overlook of the city. The tram house was the perfect place to create this sketch. The downhill perspective is more difficult to pull off than an uphill view. That is why most artists paint streams and rivers facing upstream — they just seem to look better that way.

Regardless of which perspective you select, it is important to ensure that the viewer understands your position. Keep the background in a lighter value with less detail and strengthen the value and color of the foreground. Be sure to add detail and calligraphic drawing to emphasize the nearness.

LOOK TOWARD THE HEAVENS

When strolling through city streets, I like to look above for interesting windows, rooflines and architectural patterns. St. Michael's Cathedral in Sitka, Alaska, proved to be a fine subject. There is no need to include the entire elevation of the structure but only that portion that interests you.

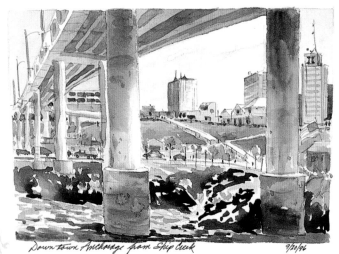

Downtown Anchorage from Ship Creek *9/20/96*

FROM BENEATH THE BRIDGE

While looking for subjects, let your eyes wander in search of a unique view. It may not be the prettiest sight, but it may say something more than a purchased picture postcard. I walked along Ship Creek in search of a subject. I found a traffic barrel on which to sit and paint. It provided an unusual perspective of the city of Anchorage, Alaska.

25

Traveling With Style

If you are an experienced artist, you probably have an established drawing style that works well for you. It may have developed quite naturally and without forethought, or possibly through instruction and practice. Your style says a great deal about you and is probably as unique as your own signature. It is an extension of your personality.

My own style is rather direct and may be considered an example of contour drawing. My eye, followed by my pen, travels over form and shape to create a panorama of my subject—a sketched outline. This technique gives me an option of adding watercolor or an ink wash to finish the picture.

A pencil sketch or a pen and ink drawing may say all that you intend. At other times, drawing can be used to strengthen a watercolor with ink detail.

Since your sketchbook is a personal journal, you may wish to jot down notations and information that describe your feelings and impressions about your subject.

I use pencil to block out areas that are important to the spatial design of the picture. The pencil sketch gives me a guide for relative sizes and placement of objects. It is done rapidly, holding the pencil on its side (parallel to the paper surface). Held in this way, the lines are soft and suggestive. If the pencil is held upright, the lines become harsh and the sharpness of the lead can make erasure difficult or even score the surface of the paper. I usually don't erase pencil lines because they give a feeling of spontaneity and energy to a painting.

Wait a Moment

I am drawing to pass the time while waiting on this street corner of the Palazzo at Lido di Jesolo, Italy. The arrival time of the bus is a mystery until, at last, it arrives. Sometimes a line drawing is all I can accomplish. This drawing is as far as I got. With more time, I probably would have added watercolor washes.

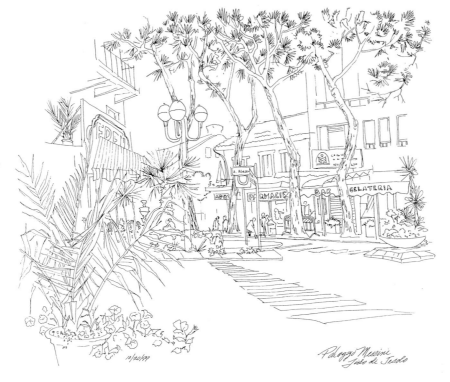

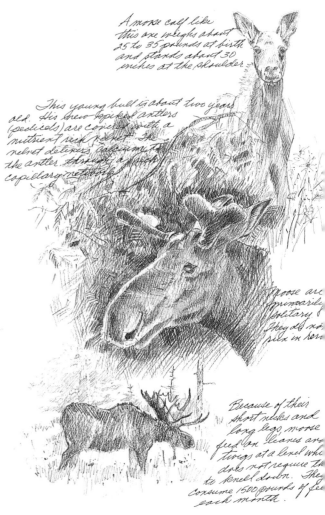

A moose calf like this one weighs about 25 to 35 pounds at birth and stands about 30 inches at the shoulder.

This young bull is about two years old. His new hopeful antlers (pedicels) are covered with a nutrient rich velvet. The velvet delivers calcium to the antler through a rich capillary network.

Moose are primarily solitary. They do not mix in herds.

Because of their short necks and long legs, moose feed on leaves and twigs at a level which does not require them to kneel down. They consume 1500 pounds of feed each month.

Moose on the Loose at Isle Royale!

Animals and people make good character sketches. My soft graphite pencil works well for drawing these vignettes of a moose. This sketch incorporates the four essential elements of a drawing: line, value, texture and form.

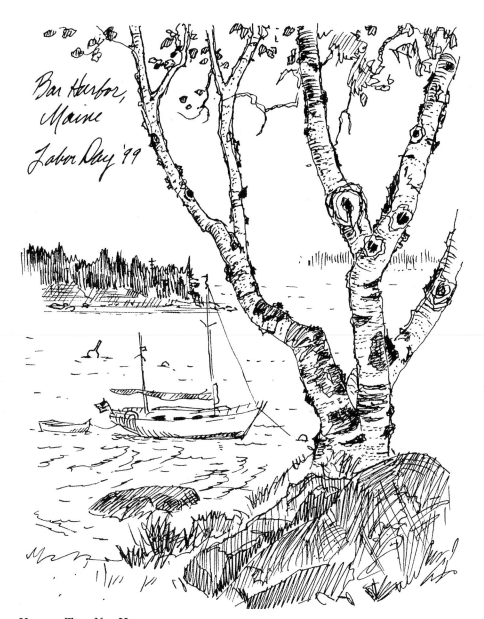

Bar Harbor,
Maine
Labor Day '99

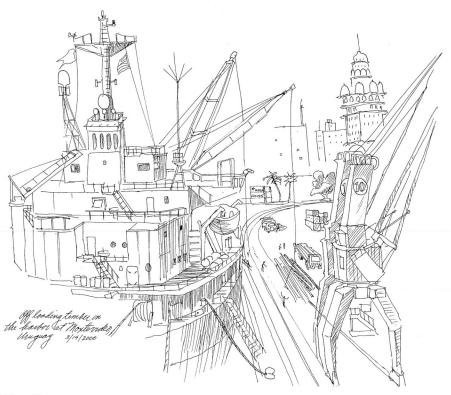

Off loading timber on
the harbor at Montevideo,
Uruguay 3/14/2000

WORK FAST

The men are off loading timber at Montevideo, Uruguay. I try to capture the essence quickly. In just a few minutes, I describe the activity with this simple line drawing. Some shading gives a suggestion of three-dimensional objects.

USE THE TIME YOU HAVE

My ship anchored here just long enough for me to enjoy a great lobster sandwich and walk through the charming village of Bar Harbor, Maine. I made a rapid pen and ink sketch while standing on the harbor trail. I try not to let the lack of time keep me from trying—sometimes I have to be satisfied with just a quick impression. I am often surprised with the results.

Drawing on Experience: Creating Pen and Ink Sketches

Pen and ink, ink markers and ink washes complement the watercolor sketches of an artist's journal and provide the advantage of immediacy.

There are many options when choosing pens. My favorite drawing pen is the inexpensive, Pilot VBall pen with an extra fine point. Sanford's uni-ball® Micro is also excellent. Even if a pen is labeled waterproof or as having permanent ink, it should be tested for ink fastness before using with watercolor. Test by brushing clear water over a sample ink drawing to determine any solubility.

Watercolor Markers

A black, watercolor marker with a broad point is another useful instrument. I don't recommend alcohol-based markers because the ink can leach through and spoil the reverse side of the page. A watercolor marker can be used to block in shaded forms rapidly and give dimension to an object.

A felt marker and a pen can create a rapid rendering. Not only is this method quick, but it provides good information about the contrasting values that would be helpful for a later painting.

Pen and Ink

I use pen and ink to strengthen watercolor sketches, especially in scenes with considerable building architecture or when there is an abundance of visual activity that needs to be defined. I prefer to begin a sketch with a pen; if my time is cut short, I have at least recorded the sight. Usually, I am able to enhance the picture using watercolor washes.

This was a fairly rapid sketch done in Provideniya, a small city in the Russian Far East. The day was cold, dark and rainy and I believe I was suffering from homesickness. This is not my characteristic style of sketching. The frenzied scratches of my pen captured the bleakness of this city street and the sadness in my heart.

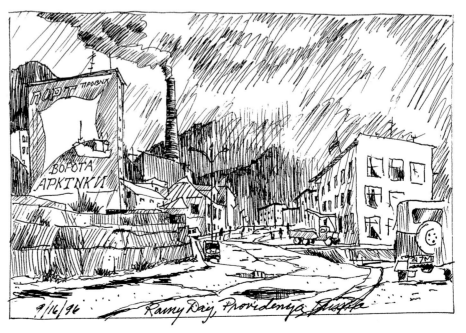

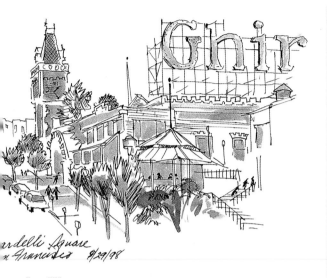

Ink Washes

A wash of permanent black ink is another easy method of creating shadow with ink drawings. Permanent ink should be premixed and blended with water to obtain the desired value. A middle value of gray can be a nice compliment for sketches. Store the ink in a leak-proof bottle and carry it in a ziplock bag for extra protection. Nalgene makes a 1-oz. leak-proof container bottle. I have carried it on many air flights without a single spill. The bottles can be purchased at stores supplying quality camping supplies. Use a small brush to apply the ink wash but be sure to wash it out thoroughly when you are finished. I use an Isabey no. 6201 folding brush made for travelers.

The simple sketch reveals just enough information to identify this familiar San Francisco attraction. I made my sketch using an extra fine, Pilot Vball pen. The picture was completed with a few strokes of a brush charged with a diluted ink wash.

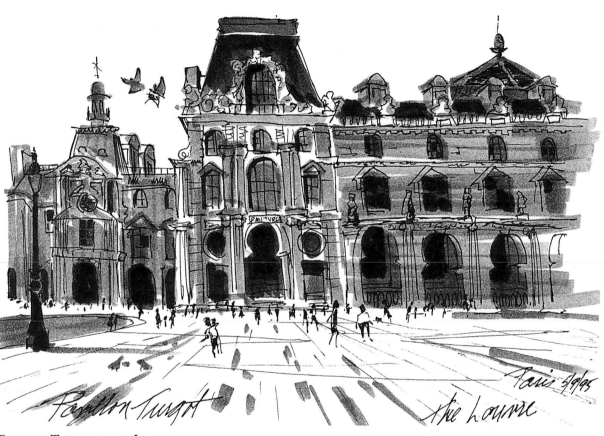

Pavillon Turgot at the Louvre

The shaded and cool portico of the building behind me provided the perfect shelter while making this sketch. I was alone when I sat down on the steps to work. It was not long before college students discovered that my steps were a very good place to sit and talk. They peered over my back and crowded shoulder-to-shoulder next to me, making sketching awkward at times. In America, people seem to like their space. For example, seats are often left vacant between strangers in a movie theater. Yet abroad, I am often greeted with unaccustomed warmth and acceptance—I like that.

Shifting Shadows

"Nobody can paint the sun, or sunlight. He can only paint the tricks that shadows play with it; or what it does to form."

—Willa Cather, from *Light on Adobe Walls*

Cather was right—one cannot paint the sun or the wind but only their influence on things. I usually begin a painting by blocking in the larger shapes and then adding the **form shadows**. Form shadows appear on those surfaces that are not in direct sunlight. They give objects a three-dimensional appearance.

Because of the shifting shadows caused by the moving sun, I wait until I am near the completion of a painting to add the **cast shadows**—ones created by the blockage of light. To insure consistency, I draw all of these shadows at the same moment with pencil and then paint them. From that point on I don't concern myself with the effect of the sun on the objects; all of the shadows will be reasonably accurate.

SHADOWS CREATE EMOTION

My sketches show my interpretation and emotional response to the subjects. For me, feeling is more important than accuracy. However, the correct placement of shadows is important to relay the scene to the viewer. Shadows can add emotion and help give a painting a feeling of reality.

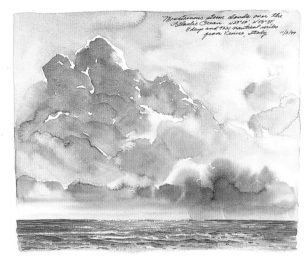

STORM CLOUDS IN THE ATLANTIC OCEAN

Claude Monet believed that while painting en plein air, light changed every seven minutes. At sea it seems to change even faster. Clouds cast their own shadows and pick up reflected light from the surrounding atmosphere.

Light is reflected upward from the building and surrounding environment, which creates a definite but lighter shadow under the roof.

This cast shadow's edge is darkest next to the sunny side of the building. The rest of the shadow is lighter because of reflected light.

Cast shadow
The darkest part of the shadow is closest to the object.

Form shadow

Vanishing point

With the sun behind me, similar objects such as these fence posts cast shadows in an imaginary line converging to the vanishing point.

Vanishing point

When backlit, these trees cast shadows that diverge away from the vanishing point as they approach the viewer.

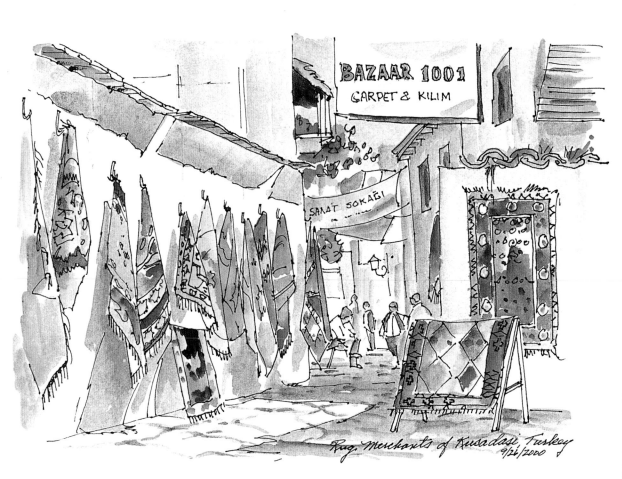

RUG MERCHANTS OF KUSADASI, TURKEY
Notice the amount of form and cast shadows in this painting. The sun moved quickly so I painted the cast shadows last to ensure consistency.

Cast shadow Form shadow

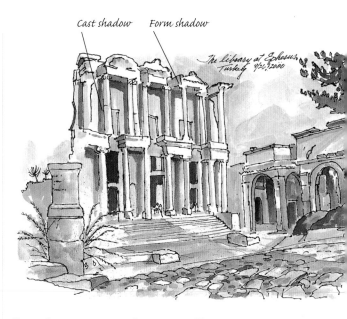

LONG SHADOWS AT THE LIBRARY AT EPHESUS
The Mediterranean sun brilliantly illuminated the steps and columns of this ancient marble structure. I literally watched the shadows cast by the columns move slowly across the inner facade as I was drawing the sketch. I added the cast shadows as the finishing touch on this sketch.

Painting the Town

Painting architectural subjects can be intimidating. There is often a visual overload of shapes and minutiae. Simplification is the key. Try to identify that which you find most important about the subject and let this be your theme. Delete all other annoying details that do not contribute to the design or subject of interest.

I attempt to create the illusion of reality by suggesting the shapes of windows and doors. I rarely put in the exact number, leaving the precise renderings of building elevations to architects. Often, the windows are placed in uneven positions to break up awkward spaces and express each building's unique character.

I often hear the comment from passersby, "I could never do that because I can't draw a straight line." But it seems to me that not drawing a straight line is actually a prerequisite for portraying buildings with character.

As you paint your buildings, express how you feel about them. Are they tired and have they fallen into disrepair? Or are they youthful and vibrant with unusual forms of architectural adornments?

You need not illustrate the entire scene. Sometimes a vignette is more effective. The viewer's eye can often fill in the blanks just as well.

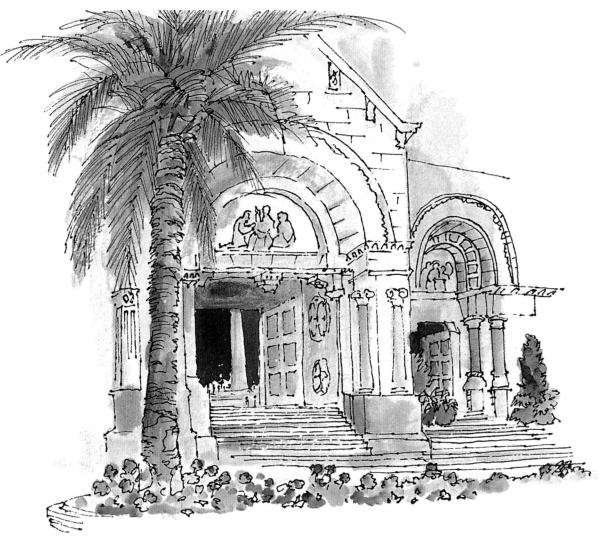

CAPTURING THE CATHEDRAL OF MONACO
I wanted to capture the entrance to this beautiful marble cathedral. Drawing every detail of this cathedral might be informative, but it doesn't add impact to this beautiful entrance. This vignette captures everything I want to say.

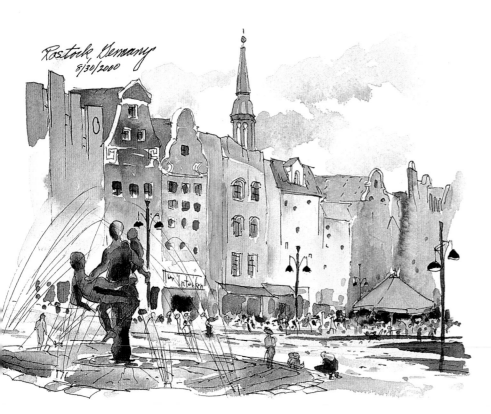

*Rostock, Germany
8/30/2000*

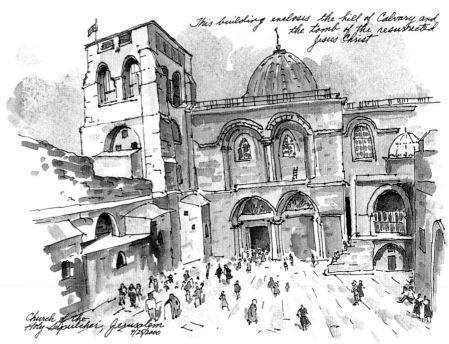

This building encloses the hill of Calvary and the tomb of the resurrected Jesus Christ

*Church of the Holy Sepulcher, Jerusalem
9/25/2000*

SIMPLIFYING THE CITY CENTER OF ROSTOCK, GERMANY

The uncomplicated shapes in the background imply the presence of buildings. Simple splashes of color separate the different architectural building forms. I try to include a few windows of different sizes and designs. Tents and shop awnings add interesting lines and color to the composition. Crowds of people in the distance are indicated as groups of heads and shoulders or individual stick figures. It's difficult to resist the temptation to add detail.

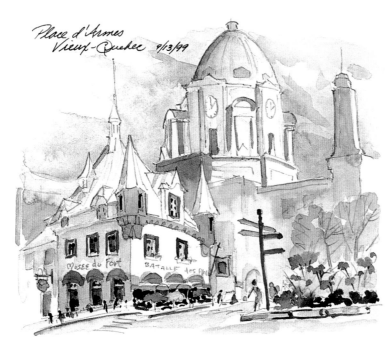

*Place d'Armes
Vieux-Quebec 9/13/99*

ARCHITECTURAL GRANDEUR

The Church of the Holy Sepulchre in Jerusalem has the emotional content and the architectural elements to create an interesting picture. The curved lines of the arches and dome play against the straight lines of the buildings and the receding perspective lines of the stone square. The cast shadows within the window arches and casements create accuracy and provide a three-dimensional feeling to the structures.

THE OLD CITY, QUEBEC

These church spires, domes and dormer windows stimulate my creative juices. In most cases, the subject needs to be simplified. The building in the lower right corner is closest to the viewer, yet I chose to leave it as a simple shape in order to accentuate the street sign and flower planter in the foreground.

San Marco Piazza, Venice: Painting With A Photo Reference

I can't be sure how you feel about your own learning process, but I can guarantee that I learned far more about this piazza from painting it than if I had just taken a photograph. Good thing I was able to do both! Photo references are not as good as painting on site, but if you don't have time to paint while on location a snapshot is the way to go. The important thing is to keep painting and practice as often as you can. Learning is what art is all about.

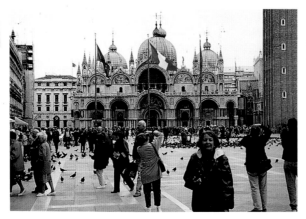

REFERENCE PHOTO OF SAN MARCO PIAZZA, VENICE
There was too much visual clutter and activity for an on-site painting and my time was limited. In my painting, I eliminated the bell tower, surrounding buildings and some of the flags as well as simplified the crowd.

1 Analyzing the Subject

Spend some time measuring space and dimensions to insure later success with this subject. Keep the pencil lines soft and free of detail.

Dampen the entire sheet of paper with clean water. Create a graded wash for the sky using a light hue of Cadmium Red and Davy's Gray and a 1-inch (25mm) flat. While damp, turn the picture upside down and apply a similar, graded wash for the piazza's marble floor. Keep the middle ground free of paint.

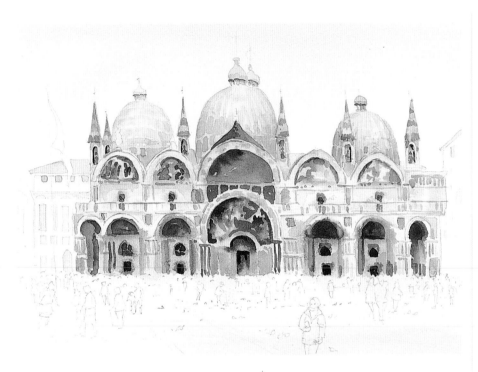

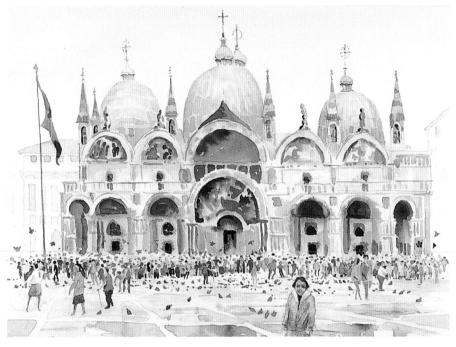

2 Creating the Impression of Detail

Turn your attention to the cathedral. You want to create the illusion of accuracy with soft pigments. Paint the warm glow of the domes using Raw Sienna and some of the remaining Cadmium Red/Davy's Gray mix on the palette. When the wash is dry, paint the remaining architecture of the church using a wet-in-wet technique. Begin with a light value wash of Davy's Gray cooled with a small amount of Cobalt Blue. While damp, continue to develop soft shapes of arches, windows and porticos. Allow the colors to fuse. Use a clean, dry brush to lift any unwanted bleeding color. Continue creating hard and soft margins as the paper dries naturally. Develop the suggestion of the figures in bas-relief within the arches, applying pigment and softening some of the edges. Be encouraged—the cathedral is beginning to demonstrate its grandeur. Now stop and rest to let your painting dry.

3 Creating a Feeling of Depth

The final stage involves the painting of foreground and detail. First, wet the area to be occupied by the crowd with clear water before painting the wet marble tiles. This will prevent a hard line from developing. Create distance by strengthening the values of the marble tile as they approach the foreground. Vertical strokes with a ½-inch (12mm) flat will easily suggest dampness and reflections on the tile.

The crowd and pigeons are purposely left until the final stage. Resist the urge to make exact drawings or to detail the people. Allow the colors to fuse and your imagination to play with the action of the individuals. Finally, add the flag and pole and the golden crosses to the domes of the cathedral.

Seeing Double

New opportunities opened up to me when it finally dawned on me that I could use both facing pages of my sketchbook to illustrate subjects. This was especially helpful for panoramic views. Now I illustrate the entire scene that I am experiencing.

You can vary the visual impact of your sketchbook by occasionally adding double-page pictures. Wire-bound sketchbooks have a definite advantage by allowing the pages to lay flat. Sketchbooks with

stitched bindings will permit painting closer to the centerfold. The one disadvantage is that watercolor pigments sometimes pool and intensify between the pages.

HARBOR PANORAMA IN STOCKHOLM
The 700-year-old capital of Sweden is without a doubt one the the world's most beautiful cities. This scene was definitely worth both pages of my sketchbook.

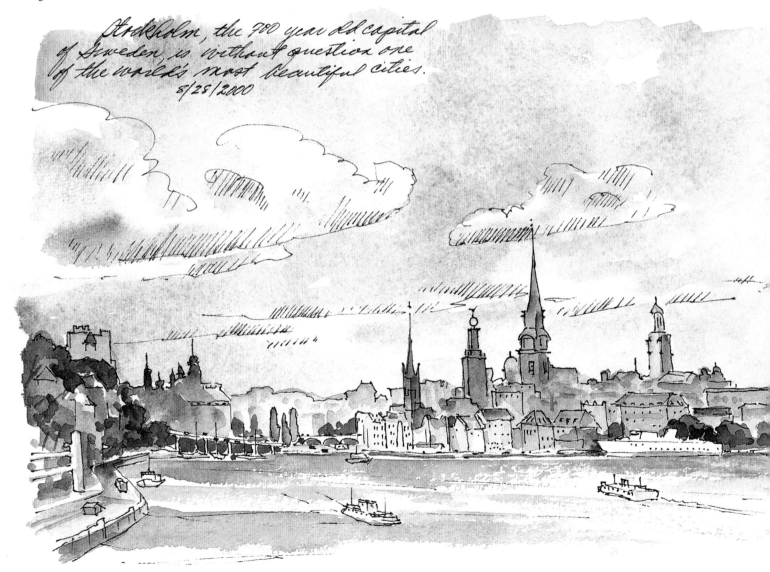

Stockholm, the 700 year old capital of Sweden, is without question one of the world's most beautiful cities. 8/28/2000

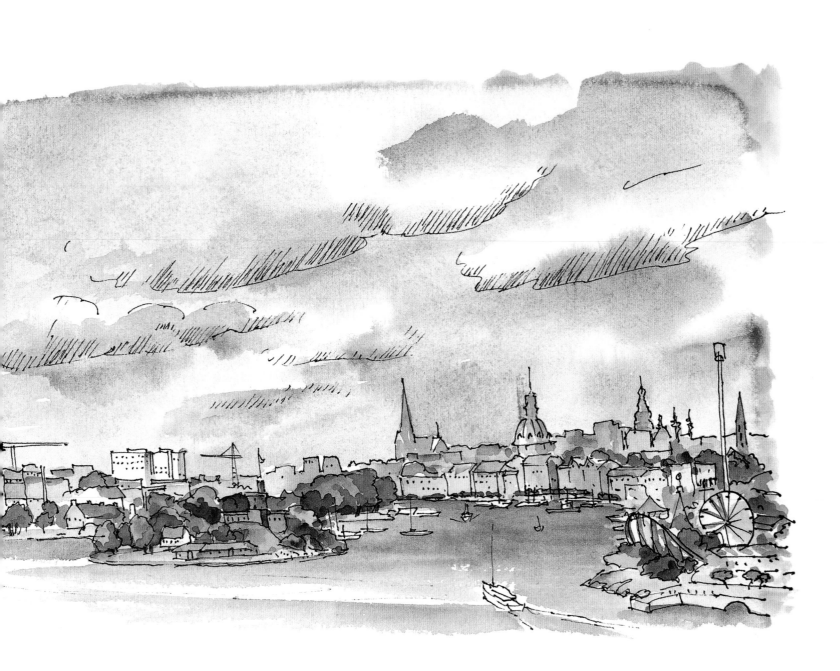

Designing Ways

The principles of design and composition are difficult to nail down. They are as tough to define as someone's personality—subjective and individual in nature. Painting on location may cause you to compromise your composition in favor of a comfortable place to work. You can either accept the visual problems as they are or use artistic license to recompose your view in favor of a better design.

I always strive to obtain balance. If a composition has a weighty form near the edge, it may cause the picture to tip. You can prevent this by placing larger or stronger-valued forms closer to the center but never exactly in the center. Lightly draw two lines on the paper, dividing it equally vertically and horizontally. This will help you align your subject without placing it squarely in the center.

Action lines are important in creating a good design. These may take the form of telephone poles, signposts, sidewalks, railroad tracks and fences. Without making clutter, add enough of these elements to give visual excitement to your composition. Be sure to include both horizontal and vertical action lines.

Juxtaposing Value and Color Temperature

Sitka, Alaska, is one of my favorite small cities. Painting subjects abound: Russian architecture, snowy mountains and fishing shacks, to name a few. I balanced the massive volcano or Mount Edgecumbe in the background with higher-key building structures and native timber that surrounded the village. The juxtaposed values of light and dark, and warm and cool pigments make this a strong painting.

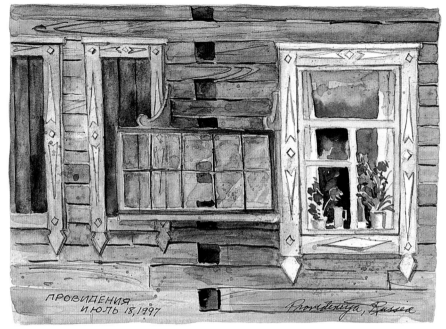

ПРОВИДЕНИЯ
ИЮЛЬ 18, 1997

Provideniya, Russia

Strong Lines Create Strong Compositions

Almost every home in Provideniya, Russia, has plants growing in the windows. It's a desperate attempt to bring cheer and color to this otherwise bleak, harsh and forgotten outpost. Notice the strong vertical and horizontal lines in this composition.

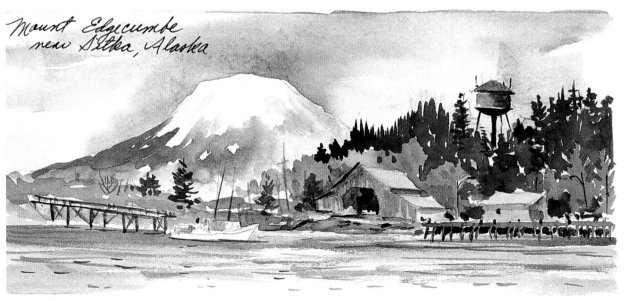

Mount Edgecumbe
near Sitka, Alaska

BOUGAINVILLEA

"...the breath of flowers is far sweeter in the air (where it comes and goes like the warbling of music) than in the hand..."
—Sir Francis Bacon, from *Of Gardens*

I placed the stunning bougainvillea flowers near but slightly above and to the left of the center of the paper. Action lines are represented by the porch supports and the fence. The curved, decorative stone leads the eye to the house and flowers.

Damage Control: Lifting Paint

"Watercolor is like a bad haircut," Karl Albert, a well-known oil painter, said to me. "It is difficult to correct!" The consensus of the public, and some artists, is that watercolor is an extremely difficult medium. But, like most activities that require a skill, it is important to know and understand the rules. Watercolor paintings can be corrected and sometimes poor paintings can be nursed back to health with a spoonful of medicine. Don't bury the victim until you have exhausted all attempts at resuscitation.

It's good to have a couple of tubes of opaque watercolor available to make repairs and clean up messy areas. I use Permanent White and Yellow Ochre gouache. They are all I need since transparent watercolor can be mixed with them for the desired color without losing the opaqueness of the paint. Gouache is a great cure when you need to reclaim light values.

Lifting paint from the surface is one of the most successful and simple procedures you can use to reclaim a picture. Occasionally, you want a certain passage to be lighter in value, or a pigment has bled into an area that should be clean and white. You can use this lifting technique to adjust or correct your painting when the paint has strayed off course.

If lifting paint fails to perk up a sickly image, try scraping the surface with a razor blade or sharp knife. Quality watercolor paper can withstand a certain amount of abuse. First, practice on a scrap of paper to see how the surface will look after scraping. Fine sandpaper can also be used for this purpose.

Add these tips to your bag of tricks. Watercolor will be your friend and not an adversary when you spend time getting to know its personality.

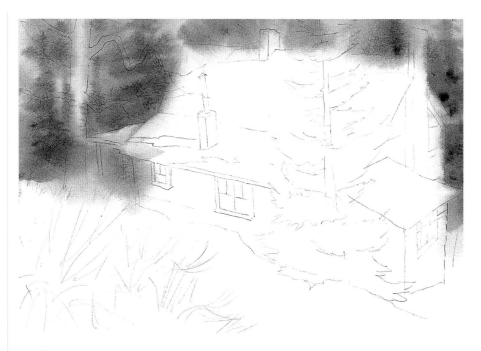

1 Setting Up House

Lightly sketch the house and the trees that surround it. Use the wet-in-wet approach for this exercise. Wet the entire paper with clear water and allow it to penetrate the paper. When the surface loses its shine and feels slightly cool or damp, use Raw Sienna and a large ¾-inch (19mm) flat to create the background and define the rooftop. Use the same brush charged with Cobalt Blue and a touch of Hooker's Green to add the suggestion of the blue spruce. Add some contours of snowy ground.

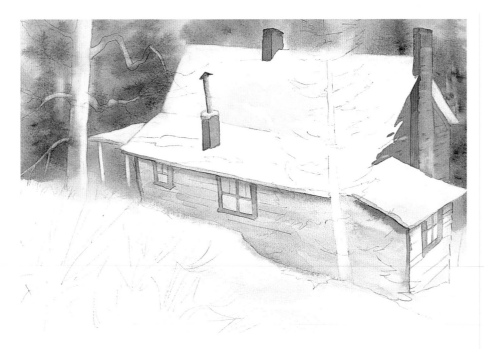

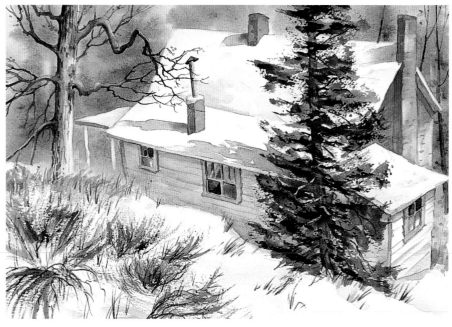

2 Roof Repairs

If the background pigment runs over the roof borders, use a small amount of clear water and a 1-inch (25mm) flat to paint the edges of the roof that need touching up. Allow the paper to absorb the water, then lift the pigment from the surface by blotting with a facial tissue. Use the same technique to clean and define the large tree on the left. Use this technique whenever you need to lighten an area.

3 Home Decorating

All that is left is the finishing work—defining the windows and adding the trees and bushes. Paint the large spruce using a 1-inch (25mm) flat charged with a mixture of Cobalt Blue, Davy's Gray and Sap Green. Hold the brush with the flat side lightly caressing the paper surface. Don't use the edge or tip of the brush. Before this pigment dries, model the branches using a darker value of this same color mixture. Add a small amount of Neutral Tint to the puddle for the second value.

Create the dark undersurfaces of the pine boughs using pure Neutral Tint, allowing it to touch and mingle with the painted surfaces above. Paint the brown grass thrusting through the snow using an old, worn out-round or an inexpensive no. 10 bamboo brush. Splay the bristles by pressing them downward on your mixing tray. Brush the paper lightly with differing values of brown, holding the brush in an upright position.

Getting Your Full Value

"The effect of brilliancy is to be obtained principally from the opposition of cool colors with warm colors, and the opposition of grave colors with bright colors. If all the colors are bright there is no brightness"

—Robert Henri, *The Art Spirit*

I am indebted to Frank Webb for teaching me the importance of a value sketch. These sketches have helped me reduce the risk of failed studio paintings by solving problems before they arise. But they can be more than just preliminary sketches when you include them in your sketchbook or produce postcards that can be sent home to family or friends.

It is very important to establish contrasting values when painting. Take a few minutes to identify the relationship between the lights and darks and block them in using your markers. If you encounter difficulty determining the value of different shapes, squint your eyes to observe the tonal value without the clutter of detail that might be in the scene.

THE VALUE OF SHADOWS

The shapes, shadows and supports for the shacks make this an ideal subject for a value drawing. I began with a line drawing and then painted the shadow sides of the buildings with a mid-value marker. A dark-value marker was used to paint the sky and differentiate the shapes of this home in Sitka, Alaska.

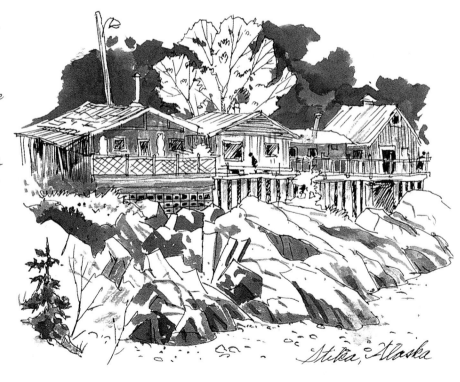

Sitka, Alaska

JOURNAL NOTE

Paper Options
Page from your sketchbook
Blank postcard manufactured by Strathmore or Canson
Any scrap of paper, if sketch is not intended to be saved

Sketching Tools
+ *One dark gray marker. I prefer water-based markers because they don't bleed through to the back of the paper. However, they are difficult to find. Some options are: Eberhard Faber Design 2 Art Marker D-112, or Chartpak Basic Gray no. 4 P229.*
+ *One medium gray marker. Some options are: Eberhard Faber Design 2 Art Marker D-110, or Chartpak Basic Gray no. 2 P227*
+ *One extra fine, waterproof black pen. Some options are: Pilot VBall—extra fine, Sanford uni-ball® Grip, Itoya Finepoint System, .1mm. Carry all your markers in a ziplock bag.*

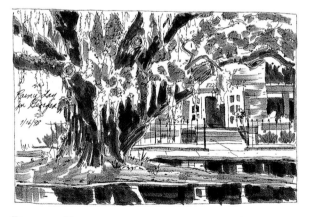

DRAWING VALUES

I began my drawing of this rainy day in Georgia with an ultra-fine pointed pen. The oak tree and its reflections are the central theme of this picture, so I sketched them first. After the home in the background was placed, I used the heavier markers to create the strong values and reflections in the standing rainwater.

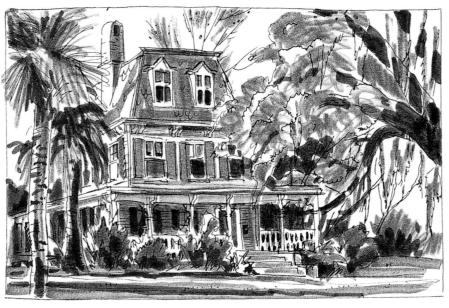

The Value of Time

No more than ten minutes was spent on this hasty sketch in Kilauea, Hawaii. After leaving my tour bus to stretch my legs I noticed this porch outside a gift shop. I would rather sketch the shapes of the porch and the adjacent flora than shop for souvenirs. It only takes a minute to add some splashes of value and turn a line drawing into a picture with depth.

The Value of Planning

This sketch of Union Street in Brunswick, Georgia, took some forethought. The problem was indicating the trees in the foreground while leaving space for the rather detailed drawing of the home. I used light pencil marks to plan the spatial relationship before using pen and ink. I used a medium-value marker for the form shadows of the house and to create the feeling of depth and dimension. A few strokes of a dark-value marker to emphasize the foreground and the darker patterns within the windows completes the picture.

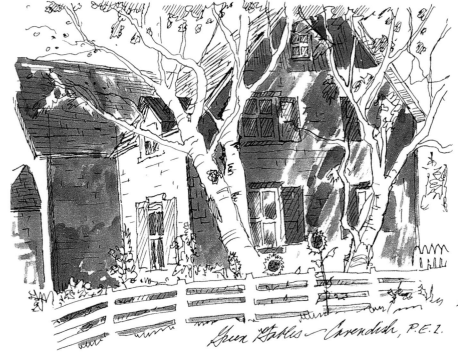

The Value of Shapes

This is Anne of Green Gables' legendary home in Cavendish on Prince Edward Island. The bright sunlight created very strong shadows and patterns. I used them to my advantage defining the angular shapes of the birch trees. The intense sunlight seemed to burn out much of the detail in the fence and tree trunks. This works well by drawing the eye to the sun-dappled side of the house.

THE OLD GRANARY: MAKING VALUE SKETCHES

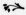
The old granary in my town has been the subject of many paintings. I can walk around each side of the structure and find inviting shapes and action lines that make a good composition. Even the same theme takes on different personalities with the movement of the sun and shadows. I try to be on the lookout for things that will add interest to my composition, like pigeons roosting on the roof line, advertisements, posted signs or maybe a forgotten shovel or broom standing against a building.

Follow this value demonstration to develop a sequence for lights and darks. Then, step out on your own with a suitable subject from your home or garden. Create a tabletop still life by arranging objects from your desk or kitchen. Bottles with labels, glassware, fruit and vegetables are all perfect for practicing this lesson.

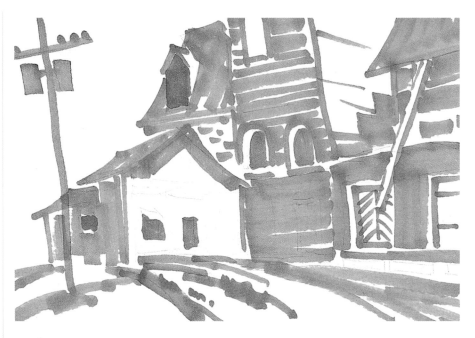

1 Block in the Middle Values

Every sketch should have at least three tonal values. Identify the middle values and begin blocking these areas with forthrightness and without concern for detail using your medium gray marker. Resist the temptation for perfection at this point.

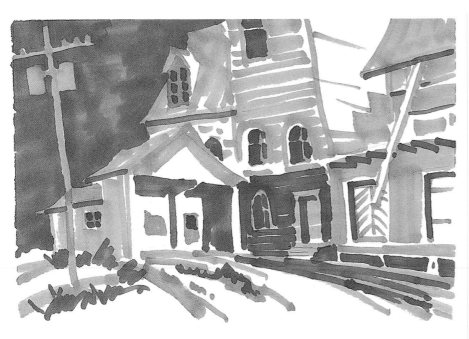

2 Create Form and Cast Shadows

Squint your eyes again and observe the darker values. With the dark gray marker, begin to create form and cast shadows. There will be a certain amount of overlapping of the middle values as you strengthen your drawing with the darker marker. Notice that your drawing consists of three distinct values: the white of the paper, the medium gray and the darker gray passages.

3 Final Touches

The final details can now be added with the black, extra-fine pen. Use the pen to indicate window shapes, foliage, telephone lines or other significant details. A word of caution: Use only the calligraphic lines of the extra-fine pen for objects in the foreground. Finally, you may wish to strengthen or accent certain areas of your picture using the dark marker.

Painting reflective surfaces can be challenging. Careful observation of water and other reflective surfaces will help you maintain accuracy. Vertical objects reflect downward at a slight slant toward the viewer's eye. Observe how city and automobile lights on a rainy night converge toward you. Reflections of slanting objects must be carefully thought out so they are mirror images. They will tilt in the same direction but opposite in their vertical relationships.

Reflected colors vary from the actual reflected object. Lighter objects go darker. Dark objects appear slightly lighter. Middle values remain about the same.

I try to create opposite tonal values of the water and the surrounding area. If the water is light in value, I darken the soil and grass. If the soil is light, I force the values by creating darker water with light reflections.

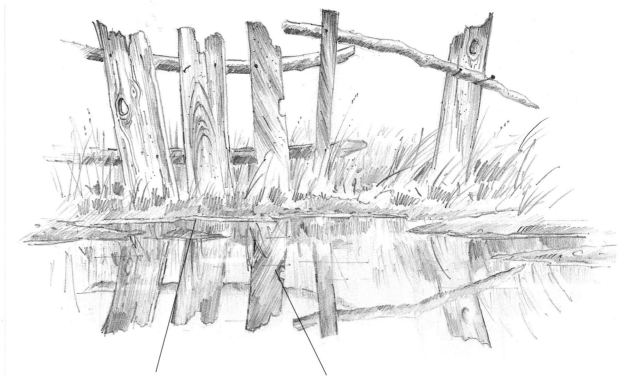

Most bodies of water, whether large or small, have a **sparkle line** of light between the water's edge and the ground of those edges that face the viewer's eye. Borders that face the opposite direction do not exhibit this white line.

From a normal viewing angle, the reflected image will be somewhat shorter, but seldom longer.

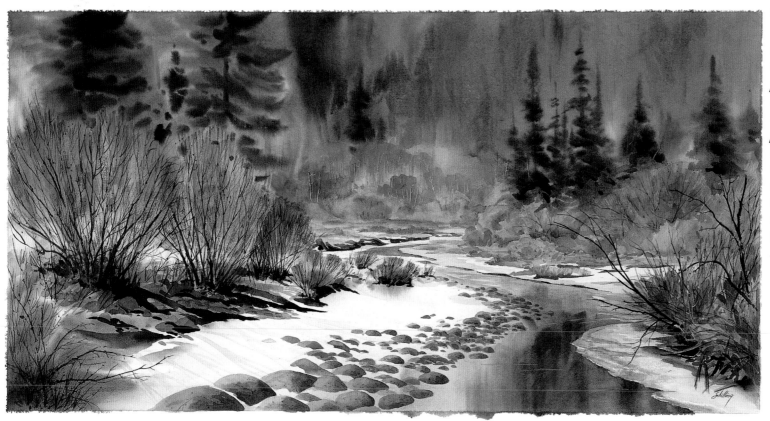

WINTER IN WILD BASIN

There is hardly a composition that cannot be improved by using reflected images. They provide an indescribable wonderment to a picture by creating a unique visual plane. I paint the watery areas with clear water and then apply clean, strong colors when the surface has dried to the point of losing its sheen but is still damp to the back of the hand.

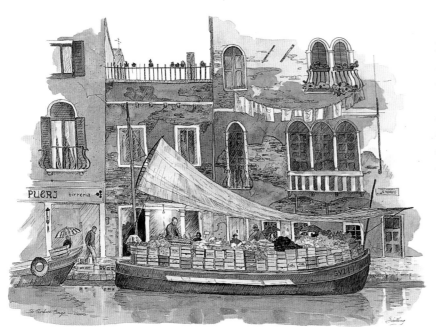

DARK REFLECTIONS

It was a wet and rainy day along the canals of Venice, Italy, but painting prospects brightened when I discovered this floating market. The merchant ran a power line from the adjacent house to his barge where he hung a couple of incandescent bulbs to chase away the darkness and better display his produce. The water in the canal was gray and murky. A few strokes of the brush suggested the shadowy reflections.

Take Ten! The Ten-Minute Sketch

It's great to spend hours drawing and painting when you can. However, if time only permits ten minutes, draw as if you only have ten minutes. The first thing to do is lower your expectations. There is no way you can create a finished work of art. So just enjoy creating an impression.

While traveling, there are always a number of opportunities to sketch. A great time is your lunch break. Draw a quick sketch at a sidewalk café while waiting for your food to arrive.

Even a tour bus excursion will present opportunities; the only prerequisite is that you win the mad dash to the restroom or endure physical discomfort until the next stop. I take out pen and paper while waiting for fellow travelers to return to the bus. True, most of the time I have not finished my sketch before the bus leaves. However, if I continue working on the moving bus for a few minutes I can finish the sketch. Often the landscape remains similar in nature. If at the end of the day I feel that my sketch needs strengthening, I can always add a quick ink wash to create light and shadow.

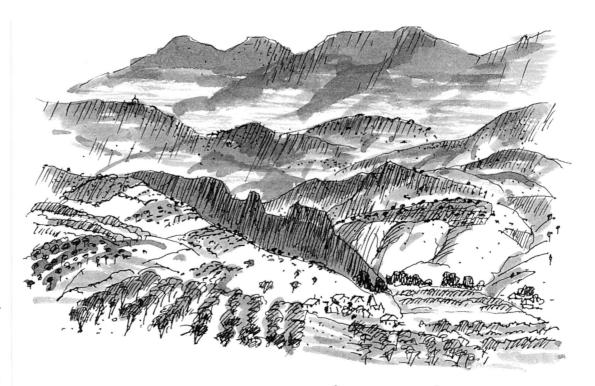

Jose Batlley y Ordóñez Park
Montevideo, Uruguay 3/14/00

Sculpture honors the cargo carriers
of the past.

SKETCHING ON THE ROAD

As our bus refueled at Los Abades on the way to Granada, Spain, I studied the fertile valley that lay below. It only took a few minutes to outline the hills, orchards and settlement with pen and ink. Later, I added the mid-value washes of ink using a small folding brush that I use just for that purpose.

MONUMENTAL SKETCHING

The tour bus stopped for only a couple minutes at this impressive bronze sculpture honoring the cargo carriers who helped develop Uruguay. I stayed in my seat by the window and hurriedly sketched the monument. I brushed on some diluted ink to give strength and character to the figures.

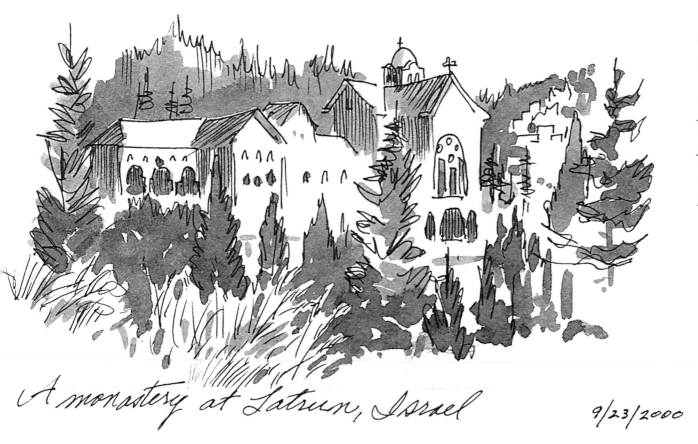

While my companions ran for the comfort station, I spied a monastery on a hill above me. I made just a few scratches of the pen to indicate the buildings. The ink wash implied the trees and foliage surrounding the monastery building for emphasis. "Where are we?" I asked the driver. "It is called Latrun," he said, and wrote the name of the place on my picture in both English and Hebrew.

A monastery at Latrun, Israel 9/23/2000

CHARACTER SKETCHES

*The sundeck of the **Nieuw Amsterdam** provided a good perspective of the yacht basin in Ketchikan Harbor. My impression of the village was made while standing and drawing at the railing. Sometimes my hurried expressions of buildings and homes have more character than my more labored efforts. It is a knee-jerk reaction. The scene is the stimulus and my pen responds without conscious awareness. It travels fast. At times, my pen travels faster than my thoughts. That's a great advantage because I don't become distracted by extraneous detail.*

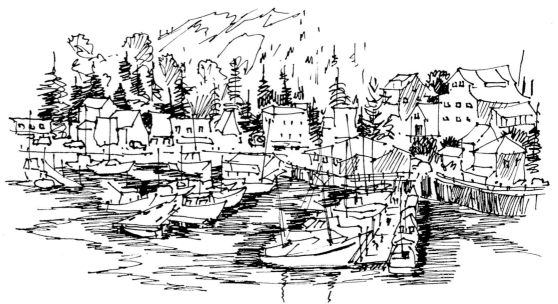

Help! It's Starting to Rain

There are two things to consider when it begins to rain: the first is your own welfare, and the second, the protection of your artwork. Usually, I am far more concerned about the latter.

I have painted in some rainy places, like Ketchakan, Alaska, which boasts of being the rain capital of the United States. But don't let a little liquid sunshine discourage you from working. It just takes a little ingenuity and forethought. Dress appropriately and look for a comfortable, dry place from which to paint.

The more difficult problem is coping with an unexpected downpour. A good idea is to carry several plastic bags in varying sizes. One should be large enough to cover your entire painting bag. Securely store your sketchbook, when not in use, in a large, waterproof plastic bag. While painting, the same bag should cover the pages opposite the working page. The book can be folded back upon itself, thereby protecting the underlying pages from smudges and paint spills.

Still, even the best of plans can go awry. And when they do, I just accept the damage to the picture as part of the memory. Light raindrops or snow falling on a dried watercolor surface will cause small blooms. On a winter scene they can be used to an advantage since they resemble snowflakes. On other subjects, they may not be quite so welcome. They give one the feeling of peering through rain-spotted eyeglasses. Well, that's OK too. How could you tell your story any better?

There are some places in the world where ideal painting days are few. After spending the night on a dairy farm near Stirling, Scotland, I asked a crusty dairyman if it was going to rain today. He gestured toward Stirling castle on the craggy cliff and said, "Ouch it's easy. Take a shuftey (look) up to the castle there. If you can see it, it's go'n rain. If you canny see it, it's awe' ready rainin'."

THE SUNNYSIDE OF RAINFALL

I never purposely go out in the rain to paint. However, neither do I allow the threat of rain to keep me from a good outing. On this day I was surprised by unexpected raindrops hitting my nearly finished painting. By the time I had it wrapped in plastic, the damage was done. It reminds me of the mist and moods that characterize beautiful, remote Isle Royale, Michigan. If my picture gets wet, I don't let it dampen my spirits. I just chuckle and remember that special moment.

SHIPS IN DRYDOCK AT PUNTA ARENAS, CHILE

I had just about finished painting when I was aware of the pelting raindrops. It was too late to protect the work: the droplets of water had already formed small white spots on the painting. It might have been better had it been a winter subject because the drips caused snowflake-like spots on the painting. The painting is OK—spots and all. It reminds me of my cold and damp visit to this southernmost city in Chile.

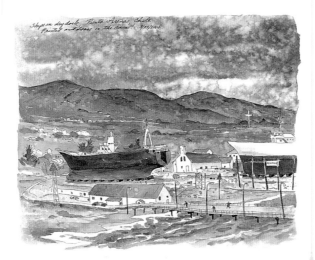

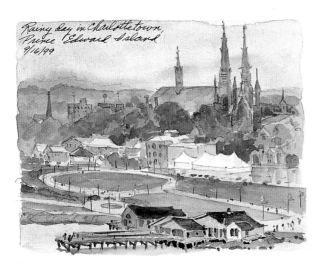

Rainy Day in Charlottetown,
Prince Edward Island
9/16/99

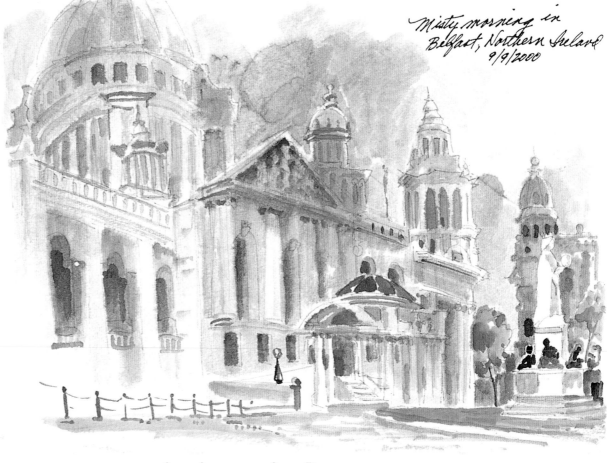

Misty morning in
Belfast, Northern Ireland
9/9/2000

STAYING DRY IN CHARLOTTETOWN

The rain was especially heavy today here on Prince Edward Island and I didn't care to get soaked wandering the streets of town. So, I found a vantage point on a protected, upper deck of my ship. I liked the elevated site and the perspective it provided me. The darker values, lack of shadows and softness captures this rainy day.

SOGGY STROKES ON A SOGGY DAY

My face felt cool and damp as I sat on a park bench in Belfast. The clouds had not yet broken loose with a torrent of rain. It's challenging to paint in the saturated humidity of Ireland, for the paper never seems to dry. The paper was limp and the brushstrokes were soft and somewhat indistinct. The conditions that I feared most became the means to portray a soggy day on the Emerald Isle.

GOOD 'TIL THE LAST DROP

I have learned not to allow inclement weather to discourage my love for discovery. Sitka, Alaska is one of my favorite small cities. I like to explore the village shops for nautical paraphernalia, books featuring local lore and hearty sandwiches with robust coffee. Nearing the time to leave the town, I painted this picture and stretched my visit until the very last tender was ready to return to the ship.

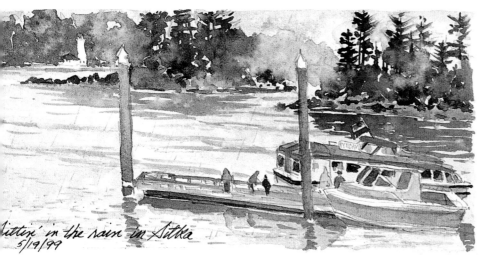

Sittin' in the rain in Sitka
5/19/99

AFTER THE STORM: CAPTURING EMOTION

– SUPPLIES –

Paints
Burnt Sienna - Burnt Umber
Cobalt Blue - Davy's Gray
Yellow Ochre - Raw Sienna
Raw Umber

Brush
1-inch (25mm) flat

Watercolor and moody subjects go well together. The nature of the medium allows the watercolorist a distinct advantage in creating visions filled with emotion and sentiment, especially when the wet-in-wet technique is handled well. There is an ethereal quality to watercolor that is difficult to duplicate with any other medium. My favorite season to paint is winter. I like the soft color of winter skies, the purple shadows and the tawny grasses that play hide-and-seek among patches of unmelted snow. This can be matched only by a rainy day in the country.

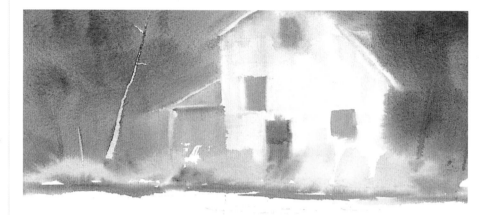

JOURNAL NOTE

Rules for Success
Here are a few of the rules I use when painting. Watercolor is such a humbling experience that I have never successfully achieved all of them in the same effort.

- *Never give up on a painting until you have brought it to completion. Early judgment is not reliable.*
- *Paint the background loosely with broad strokes.*
- *Resist the temptation to rework or add detail to the background.*
- *Practice and discover from experience the right time to add pigment to dampened areas. Once mastered, use this tool to create incredible depth to your paintings.*

1 Set the Scene

Make a soft, simple pencil sketch. Don't define the subject too closely. This allows for spontaneous things to happen when you begin your background wash. Paint the top half of the picture using the wet-in-wet technique. Dampen this area at least twice with clear water and allow it to mellow. When the surface loses its wet look yet still feels damp to the touch, you are ready to begin.

With a 1-inch (25mm) flat, paint the shape of the house using a light shade of Cobalt Blue, Davy's Gray and a small amount of water. Add very light Yellow Ochre to play with the blue-gray of the building.

Paint the area surrounding the building with umbers and siennas, allowing the colors to mix and blend. Place a dash of Cobalt Blue here and there for a sky that plays peekaboo among the trees. Resist any temptation to create detail. As you continue to work you may discover darker pigments bleeding into the shape of the house. Repair the areas by lifting the pigment with a clean, dry, flat brush. You may need to repeat this procedure several times, but the end result will be soft and attractive edges.

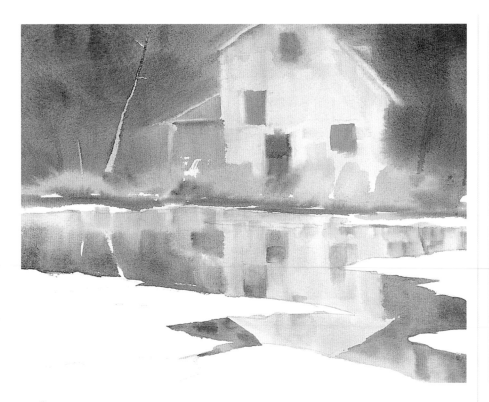

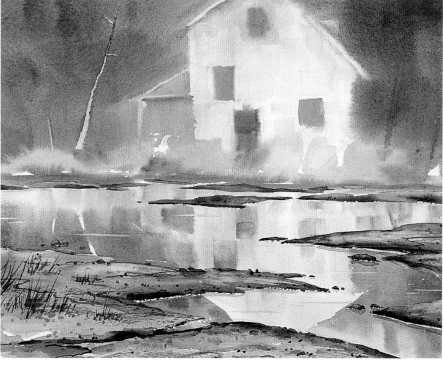

2 Paint the Watery Reflections

Paint the area of standing water as the reverse of the wet-in-wet background from step one. There are some slight differences to keep in mind. The basic rule is that darker passages will reflect slightly lighter in water, light ones reflect somewhat darker and middle values remain about the same. It does not always work that simply. When painting wet-in-wet there is a very limited time in which to work so if you error in this rule, no one should fault you if the reflections aren't quite right.

Paint the area of the standing water with at least two coats of clear water. Let it stand for a few moments while you gather courage and take a deep breath. With a vertical stroke of your 1-inch (25mm) flat, repeat the colors from the background. Rinse your brush and repeat with different pigments, allowing them to flow and blend with neighboring colors.

3 All That Remains Is the Fun

Paint the exposed ground with Burnt and Raw Sienna and Davy's Gray. The edge of soil next to the water always has a greater saturation of water and should appear darker. Add some texture to the ground and a few dirt clods that are exposed above the water.

Finish the water by creating that sparkle line on the water's edges that face the viewers. If you have not left this area unpainted you can easily create the same illusion by scraping pigment with a sharp, pointed knife blade. Finally, to make the water believable, take a swipe through the painted area using the chisel edge of a clean, flat brush. This can be repeated two or three times but always with a clean brush. Don't even think of making a second swipe without first washing out your brush in clean water.

Remarque-able Paintings: Pencil With Watercolor

The *Oxford Universal Dictionary* defines remarque as a "distinguishing feature... usually consisting in the insertion of a slight sketch in the margin."

At times I like to add small drawings in the margins of my sketchbooks. These serve as a change or relief from the otherwise uniform pages of watercolor paintings. They are postscripts to the statements made above them and add a bit of interest to the page.

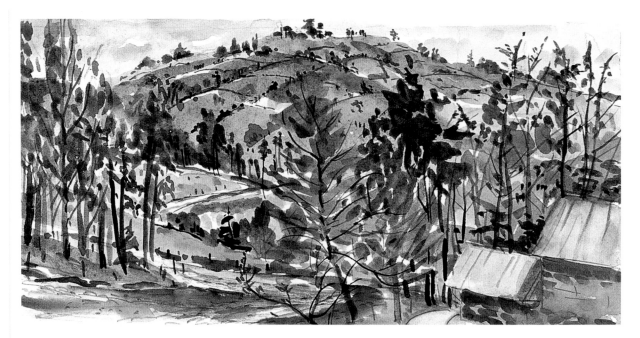

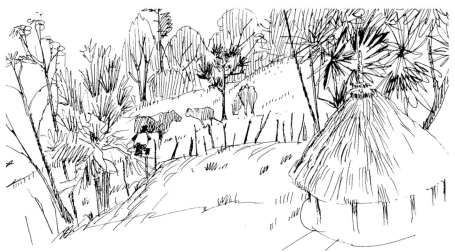

CREATING A SETTING
This road is a busy route to the hospital; most people walk many miles to their work. In the line drawing, a farmer milks his cow after first tying her calf to the tree. Line drawings like this one add an element of interest, detail and texture to the painting, while capturing the essence of the experience.

A Study of a Moose Antler From Isle Royale, Michigan

Moose antlers are grown and shed annually. They appear as stubby, velvet nubs by early May and grow rapidly throughout the summer. This requires the male moose to ingest huge quantities of calcium-rich foods. By the end of August, the blood supply to the antlers begins to wane and the velvet forming membranes dry and are shed. The white-tipped antler is polished and stained brown by the bull moose incessantly rubbing them against small tree trunks. After the rutting season, in late December, the bulls jettison their heavy, antlered baggage and the process begins again.

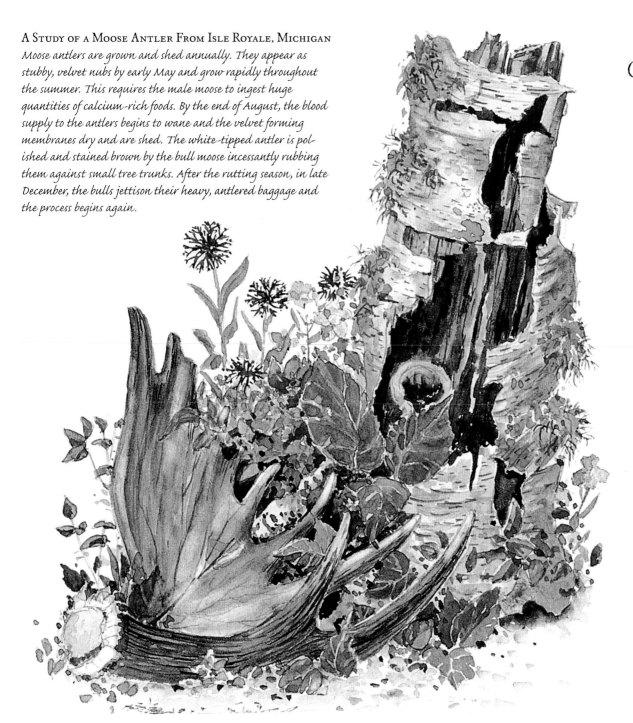

Journal Note

Paradise Found—Isle Royale, Michigan, 1996

July 2, Scoville Point: I found the cottage that would be my home for the next three weeks sequestered under pines and birch trees on a rocky promontory thirty feet above the waters of Tobin Harbor. Inside, the cottage walls and furniture are slightly askew to a plumb line, yet they welcome me as a similarly flawed friend. The wavy windowpanes sparkle with jewel-like air inclusions. A skilled stone mason built the fireplace and hewed a decorative mantle from a large log. Even though it is now late in the evening, the light is only beginning to fade. It has not been necessary to burn the kerosene lamps. Tomorrow I will explore the island for watercolor subjects.

July 19: The cottage screen door slammed shut this morning as I headed down the path to the outhouse that bore the inscription R.I.P. The sudden intrusive noise frightened a bull moose that had been standing beneath the eaves of the cottage. He thundered down the path, narrowly missing me. For days I had seen fresh tracks next to the cottage windows but was unable to catch the window-peeker in the act. It caused me to reflect—who had come to observe whom in this magnificent, north woods wilderness?

Moose

The Algonquian Indians named this strange looking creature **moose**, *which means* **twig eater**. *Their presence was considered a good omen.*

Going the Distance: Creating Depth in Pictures

Creating distance in watercolor paintings creates tremendous impact. The trick is in the execution to achieve this illusion. The general rule suggests that distant objects are softer and cooler than objects in the foreground. With watercolor we have a distinct advantage that allows us to quickly and effectively soften edges. By dampening the paper surface and adding pigment at the proper moment, we can achieve remarkable depth. Our oil painting friends must struggle to achieve that same level of softness.

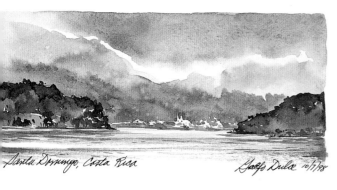

Santa Domingo, Costa Rica

Golfo Dulce 10/7/98

LAYER TO CREATE DEPTH

To create a feeling of distance in the Golfo Dulce in Santo Domingo, Costa Rica, I allowed the clouds to play peekaboo with the mountain tops. I then silhouetted the homes and spires of the village church with darker values to create the impression of a village.

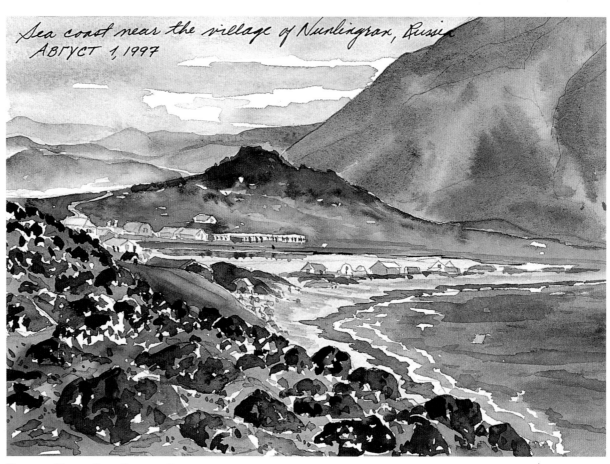

Sea coast near the village of Nunligran, Russia
АВГУСТ 1, 1997

KEEPING VALUES LOW CREATES DISTANCE

The volcanic ash-littered hillside provided a good view Nunligran, Russia, the whaling village that had been my home for the month. Clouds shrouded the distant mountains, but at least they had not yet unleashed their spitting rain and sleet that day. I wanted to convey my feelings for this place: the abandoned and decaying houses on the beach, the depressing array of cages full of foxes on the distant hill, and especially, the topography and weather characteristic of the Arctic coast. To keep the mood, the picture had to be kept less than bright. I blended the gray, threatening clouds into the ethereal mountain ranges. I kept the color values low in order to push the distance and accentuate the foreground against the distant mountains.

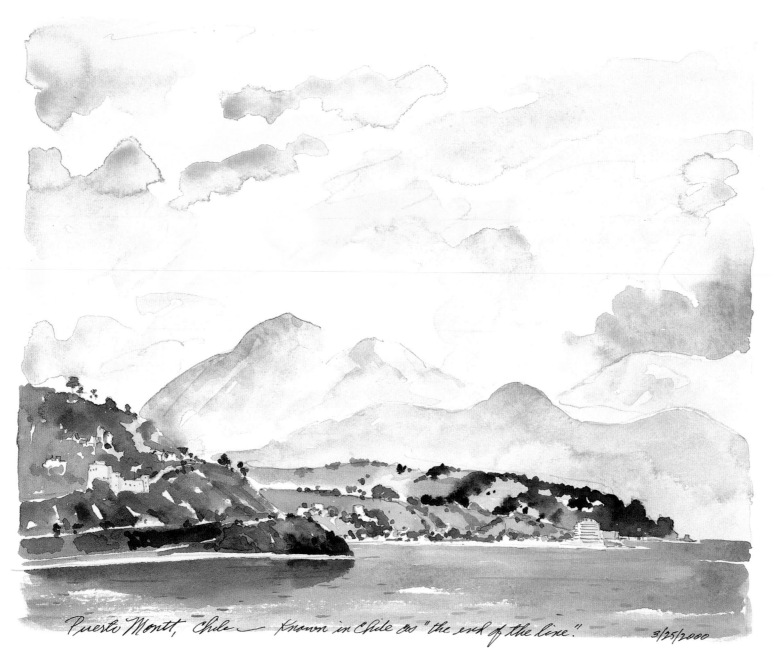

Puerto Montt, Chile — Known in Chile as "the end of the line." 3/25/2000

THE ANDES MOUNTAINS,
PUERTO MONTT, CHILE

Another cloudy day, but for one glorious moment, the sky lightened to display the fertile, coastal hillside. This subject is easier to execute than it might appear. The clouds and sky were painted with pastel colors directly on the dry paper. After each application of color, I picked up a very small amount of clear water to touch and soften some of the painted margins. I juxtaposed the strong values of the hillsides against the soft mountains, bringing these areas to the forefront.

CREATING DEPTH IN LANDSCAPES

The rule to remember is: Objects in the foreground must be darker in value and more distinct in clarity. The eye is much like a camera. It can only focus accurately on one depth at a time. Painting too much detail in the background has destroyed the impact of many otherwise good paintings.

When painting landscapes, be mindful of the direction from which the sun is shining when placing the shadow areas of the mountains. Your shadows should help define the land and accurately depict the scene you are painting.

Use the placement of trees and other objects to define the landscape; they should form the foothills by describing their contour. Remember that objects in the distance are lighter in value and intensity, as well as less clear. Your trees should reflect this principle. Begin this painting with a soft, loose drawing of the larger forms, avoiding hard lines and detail.

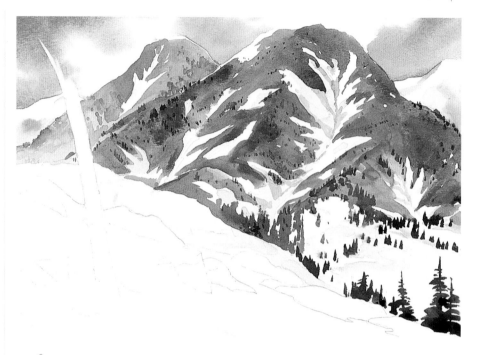

1 Creating a Soft Background

Use a 1-inch (25mm) flat to apply clear water to the top two-thirds of the paper. When the paper looks dull but is still damp, add Cobalt Blue using the 1-inch (25mm) flat to the dampened surface, leaving some white paper for cloud formations. Dry with a hair dryer.

Begin the mountains using a 1-inch (25mm) flat loaded with Raw Umber. Add some Davy's Gray at the edge of the Raw Umber and allow it to fuse. Keep the distant mountain range soft in color and light in value. Strengthen the closer mountains by fusing the pigments on the paper. Add other pigments to build the contour into the mountains.

Add the evergreens on the hillsides. Paint the more distant trees softer and cooler, but darken them in value as they approach the middle ground. Mix the greens using Cobalt Blue and Cadmium Yellow Pale. Adjust the amounts of each to produce either warm or cool shades of green. Hold the flat brush with the chisel-shaped edge vertical to the bottom of the picture with the handle at a 90 degree angle. Touch the bottom tip of the brush to the paper to create a triangular shape that suggests a pine tree. Boldly create a few strokes to indicate the mountain's contour. While damp, touch the edges of the contours with the vertically held brush to paint more trees. Emphasize the roundness and contours of the mountain slopes by wisely planting the pine trees.

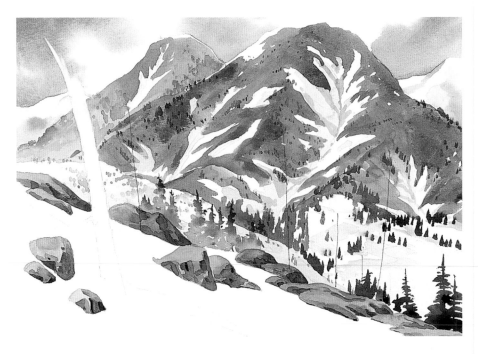

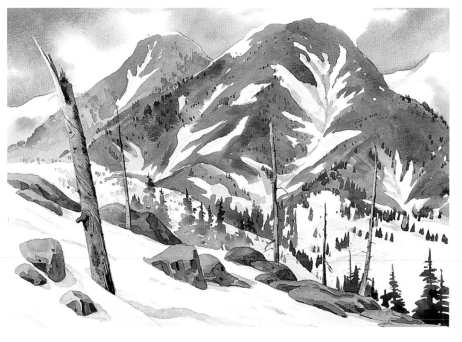

2 Mountain Approach

Paint the middle ground that is much smaller in area. Dampen the snowy field with clean water and add more trees to the middle ground. Add a small stand of evergreens to the center section. Create modeling and shadows on the middle ground using light Cobalt Blue washes. Adding a darker value to the pines on the right will bring the painting forward. Develop the outcropping of rocks using light, medium and darker values of Raw Sienna, Raw Umber and Sepia to create roundness. Resist the urge to paint detail; that comes next.

3 Create Spatial Separation

Now you are ready to force the distance by painting the foreground detail. The twisted, windblown tree trunks nail down the foreground. Paint these trees with a no. 8 round to puddle different pigments beginning with Raw Sienna into the dampened trunk body. Create roundness by touching the shadow side while damp using Raw Umber, Payne's Gray and some Neutral Tint. After drying the surface, add more character and twisted lines using the riggers. Lastly, paint the soft shadows that describe the surface contour of the snowy slope.

Faces in a Crowd

sketching in public can be great fun. But first, you must shed all inhibitions and any illusions of perfectionism. I prefer simple contour and gesture drawings using either pen or pencil. I am not after accuracy but try to capture the posture and attitude of the people around me.

If you are sketching within a crowd of people, you will probably remain unnoticed, so try not to feel self-conscious. However, sometimes your sketching will become obvious to others, and people will react differently. Some subjects will get up and leave or turn away if they are aware that they have become the focus of your attention. If you are doing a close-up, be courteous and ask the subject's permission for a portrait.

A word of caution: In some cultures, taking a picture is considered "capturing one's soul" and people may be vehemently opposed to photographs. If people are in the foreground it is always best to ask permission for a photograph or a sketch. A painted portrait is often acceptable. On several occasions, I have sketched individuals who then thought they owned the artwork. This can be a sensitive issue.

I carry a pocket full of United States golden dollar coins to use as gifts of appreciation—they are a big hit. As another token of appreciation, I write the person's name and address in the sketchbook and mail them a matted color copy of the portrait.

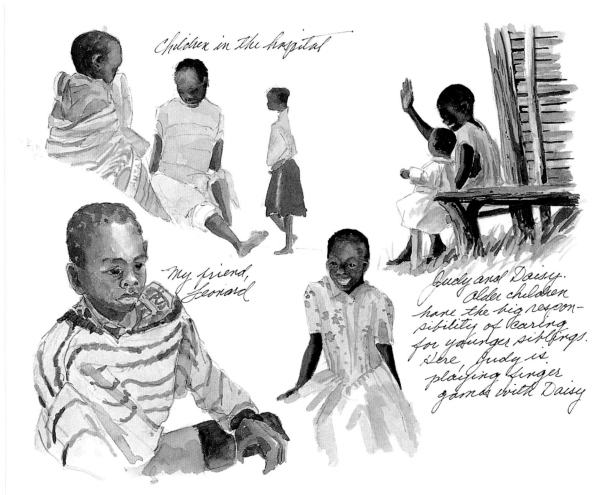

Children in the hospital

My friend, Leonard

Judy and Daisy. Older children have the big responsibility of caring for younger siblings. Here, Judy is playing finger games with Daisy

THE FACES OF CHILDREN

Children are fascinating to observe and draw, but once they realize what you are up to, the session will be over. They are mesmerized when I work and I often find myself encircled by youngsters until further sketching becomes impossible. I was painting a landscape along side a road in Africa. Within minutes, small, barefooted children with eyes like eagles, came running down the paths from the hillside farms to see what I was doing. It was a challenge to stay focused on my work while they made me laugh. Children slowly and cautiously rolled up my pant legs, snickering at a sight they had never seen before—pink and hairy legs. A small boy, his face inches away, peered into the strange, colored glasses that covered my eyes. I was an amusing curiosity to these children.

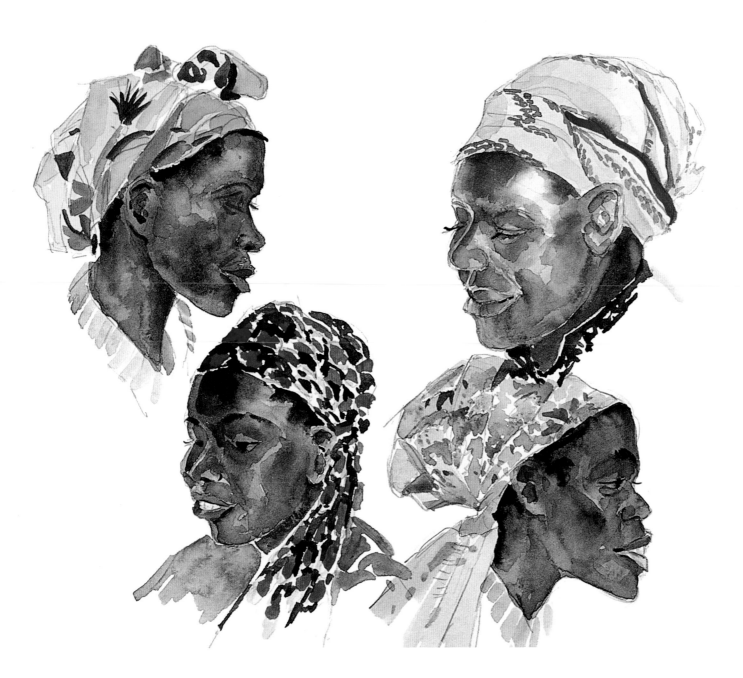

Recording Culture

The African scarf is both a functional accessory and a beautiful adornment. It can be tied around the head in many different ways or converted to a carrying sling for a small infant. Women wear them with natural flair, making them stunning subjects for portraits. I asked the women in this illustration to demonstrate how they wear their scarves.

Through the years I have accumulated a number of sketchbooks, many of them similar in size and binding. I have solved the problem of identifying each book by creating covers that best represent the work inside. Several of the books contain sketches from single trips, but you may wish to identify your sketches by individual subjects, such as children playing in the park.

I choose a picture from within the book to make a high-quality color copy in a reduced format. It is laminated and then trimmed to within 2 or 3 millimeters of the picture margin. Rubber cement is painted evenly over the reverse side and the picture is pressed to the cover's surface. Any excess cement that squeezes out can easily be rubbed off without staining the book cover. Rubber cement also allows for flexibility in the cover without losing its bond.

Title pages decorate and introduce the purpose of the sketchbook. I like to design a title page for those sketchbooks that are devoted to a single subject. You may wish to keep a book just for visits to the beach or vacations in the mountains.

I often leave the first page blank when starting a new sketchbook. Later, I return to add a decorative title, or I fill the page with another sketch if the book becomes general in content. Remember to add information or dates. This will prove very interesting as the years go by.

I use different styles of lettering to make the pages attractive. You can use your own unique style of printing, or when creative juices dry up, consult a lettering stylebook for good ideas.

TITLE PAGE FROM PAINTINGS IN THE RUSSIAN FAR EAST
Chukotka is truly one of the ends of the earth. I had to consult a map to find out where I would be working. I designed the map to help others locate this remote area of Russia. The title page shows a typical Eskimo next to the beach outside my modest clinic. This title page accurately summarizes the central theme of the journal.

TITLE PAGE FOR A EUROPEAN JOURNAL
You may wish to design your title page after you return from your trip, as I often do. I leave the first page of the sketchbook blank for this use. Upon returning home and reviewing my journal, I have a good idea of what should be the central focus or message. For this mini-world cruise, I borrowed the technique from early illustrators who used stylized lettering and painted images. If stumped, I look for lettering ideas in one of the many helpful guides to pen and brush lettering.

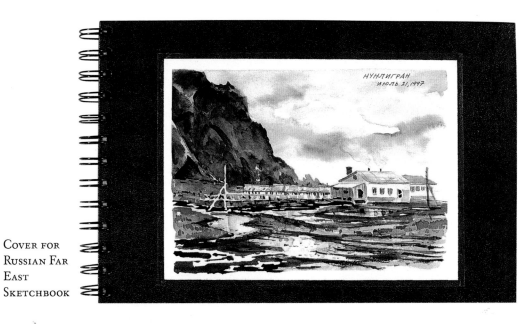

НУНЛИГРАН
ИЮЛЬ 21, 1997

COVER FOR
RUSSIAN FAR
EAST
SKETCHBOOK

Chronicles of a Volunteer Dentist in East Africa

by
Richard Schilling

COVER FOR AFRICAN
SKETCHBOOK

COVER FOR PANAMA CANAL SKETCHBOOK

COVER FOR ISLE ROYAL
SKETCHBOOK

Plants and Flowers

Flowers and artists seem to have an artistic affinity. The simplest bloom is a miracle of creation and beauty. The watercolorist is never without a subject for painting when flowers abound.

During the non-growing season artificial flowers can be used effectively. Although these flower reproductions are often created with amazing accuracy, the leaves sometimes are not as believable. The artist must recognize this failure and use caution when painting the foliage.

Find a simple arrangement of fresh or artificial flowers. Resist the temptation to draw them with accuracy; instead, experiment by flowing in different pigments to a dampened surface. Finish by defining your subject. Don't take your work too seriously and enjoy the experiment. I think you'll like the results.

Flower Shopping in Venice

These women must be mother and daughter! What a delightful moment to capture. The young lady's red suit vibrates with the complementary green of the foliage. Complementary colors add a little bit of tension to a painting, creating interest and excitement.

Flowers From Isle Royale

These indigenous flowers were recorded in my diary during my stay as Artist-in-Residence at Isle Royale National Park during the summer of 1996.

Flowers of the Maasdam
9/18/99

Shrimp plant

Tegucigalpa,
Honduras
3/1/98

Victoria, B.C.
Butchart Gardens

5/28/96

PERFECT FLOWERS

This beautiful floral
arrangement with its
blooms of large sunflowers
was the perfect subject for
a watercolor. Flowers like
these are plentiful on the
M.S. Maasdam.

THE SHRIMP PLANT

While providing dental care to the poor in Honduras, my
wife and I were greeted by this colorful and unusual plant.
Look for unique specimens wherever you are travelling—
you never know what you may come across.

HIBISCUS IN BUTCHART GARDENS, VICTORIA, BRITISH COLUMBIA

One of the world's finest gar-
dens beckons the artist within.
There are subjects to paint at
every turn.

POPPIES IN VAIL: PAINTING ALLA PRIMA

*This painting will be developed in an **alla prima** style—completing a painting in one sitting. This traditional method of painting from life forces the painter to make decisions and work quickly, placing color decisively and directly where needed. In the early stage of the painting it is important to keep pigments transparent and luminous. Poppies in the spring are one of my favorite sights, and I couldn't resist painting them.*

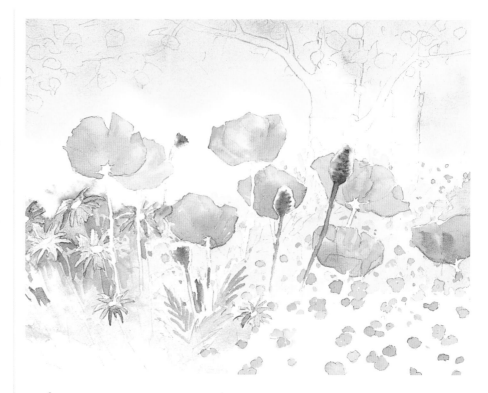

1 Create the Underpainting

Make a pencil sketch of the subject. Plan carefully, placing the trees and blooms in the correct positions. Paint the lightest values first—the aspen leaves, poppies and the green foliage of the foreground. Use different shades and temperatures of green by mixing variations of Cobalt Blue and Cadmium Yellow. Change the color temperature by mixing different proportions of these two colors. All plant varieties differ in value and temperature, some being warmer or cooler than others. Complete the underpainting for the poppies with a no. 6 round dipped in a blended wash of Rose Madder and Cadmium Yellow.

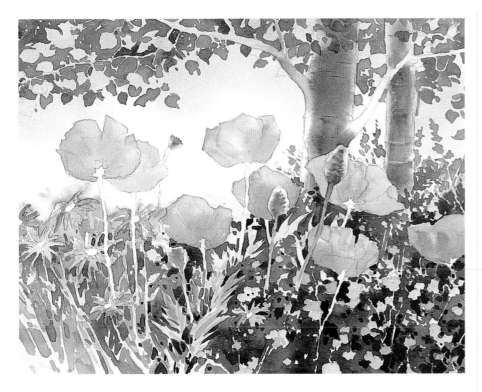

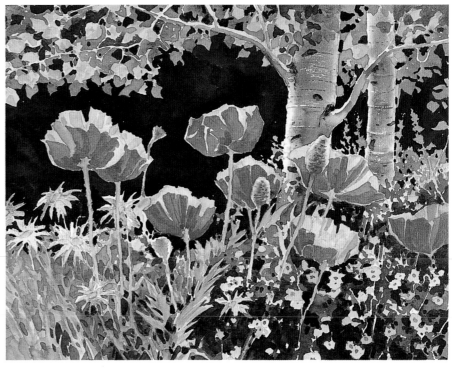

2 Paint the Landscape

Paint the trees and flowers using middle values of pigment. Paint the aspen trunks with clear water and brush a desired shade of green into the center one-third of the trunk with a no. 6 or 9 round. Allow the pigment to flow toward the outside edges of the trunks. Paint each one separately and allow them to dry. Practice this technique on some discarded paper to get the feel. Puddle other pigments into the green as desired. Warm up the green with Burnt Sienna if it becomes too electric. Apply Neutral Tint to the shaded portion of the trunk to strengthen the value. Apply it while the green trunk is still damp.

3 Nurturing the Flowers

Now you can begin to enjoy the flowers of your garden. Define the foliage and flowers of the foreground, placing darker values of similar pigments in the deeply shaded areas. Paint the dark green background by mixing a large wash of Permanent Sap Green and Neutral Tint to the desired value. Test it on a scrap of paper. Begin painting around the aspen leaves to test the value of the background. If you are right handed, begin painting from the left side of the picture. Don't hurry the painting, but do not allow the painted edge to dry as you work across the sheet. Keep applying paint from your pre-mixed wash to the edges before they begin to dry. This technique gives you a consistent wash with the time needed to carefully paint around the lighter objects. Your garden will come to life as you add depth to the aspen leaves and shadows in the foliage.

Home Is Where the Heart Is

I met up with Inna, a Russian college student, in Anchorage, Alaska. She would be my interpreter for the next month in the Russian Far East. "Are you excited to be going home?" I asked. She responded indifferently with a shrug of her shoulder.

The twin engines of our private plane droned monotonously for hours above the icy regions of the Bering Sea. Finally, with relief, I saw the dirt landing strip for the town of Provideniya, Russia, appear through the clouds and mist. The small plane skipped as the wheels touched the rough runway and at that moment a scream rang out from the back of the plane. "I'm home!" Inna shouted.

Like Inna, we are not always aware of that inexplicable draw of our home or homeland. It is like a lodestone that tugs at our human spirit. I have, to this day, a fondness for memories of all my temporary homes in foreign lands including the most humble of dwellings.

GOODBYE AFRICA, FAREWELL MY SUNNY DEN

I recorded this memory by illustrating my favorite room — my studio and den — during my stay in Africa. At my desk, I painted and wrote entries to my African journal. From my cheery room with large windows I watched the rain showers drift lazily across the hilltops of western Kenya.

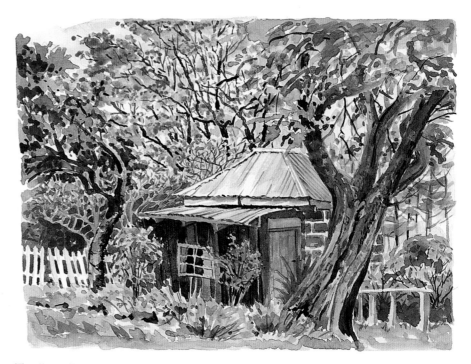

THE BLUE DOOR

Today I went with Sam Powdrill in his Land Cruiser to the clinic at Kaboson. The village is located on the fringe of the Kipsigis country, adjoining the Masailand. The jacaranda were in full flower along with the bougainvillea. I spent one hour on this watercolor of a small cottage framed with beautiful flowering trees.

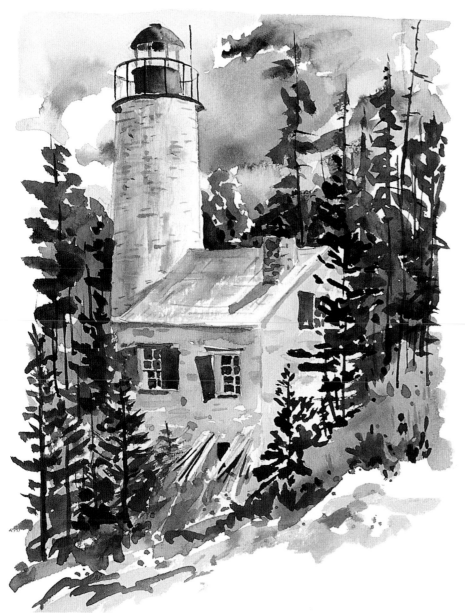

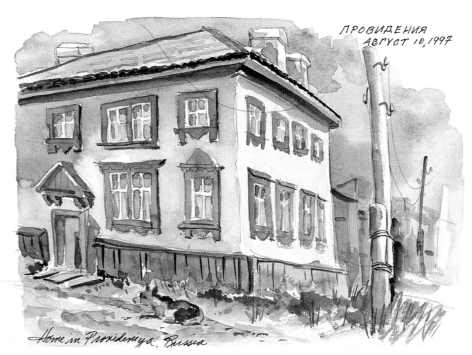

ПРОВИДЕНИЯ
АВГУСТ 10, 1997

Home in Provideniya, Russia

FULFILLING DREAMS

Isle Royale National Park is an international biosphere in the northernmost part of Lake Superior. For one month I was able to fulfill my dream of sojourning on a remote, island wilderness with a couple of good books, my paints and Marlene, the love of my life. Our cottage was sequestered among the pines and birch on Scoville Point high above Tobin Harbor.

KITCHEN PLUMBING

This is the kitchen of my two-room home away from home in Nunligran, Russia. This sketch illustrates my Spartan living quarters with my "running hot water." My water supply originates from a hot-water radiator and flows sluggishly to the wash basin in varying shades of brown.

HOME IN PROVIDENIYA, RUSSIA

This large home was probably built in the 1930s. It was constructed with massive walls to help insulate against the relentless winter storms. To enter you must go through a series of doors and anterooms that conserve the inner heat. I tried to capture the carpenter's skill in creating the ornate wood windows and door trims.

Welcome Home: Friendships and Dinner Invitations

Many doors of friendship have been opened to me because I am both a volunteer and an artist. In some remote areas of the world I am the first artist that some people have ever seen. Especially in small, third world countries, I am sure to draw a crowd of onlookers whenever I paint. I enjoy interacting with people of other cultures even though I may not be able to speak their language.

JOURNAL NOTE

Creating Friendships

I went across the street from the hospital and painted a picture of a duka (shop) where a tailor was hard at work. As usual, I attracted a large crowd of people. Small boys perched on the fence rail behind me while others climbed a tree for a better view. Soon the people encircled me and I could no longer see my subject. I stopped every few minutes and motioned to the crowd to open the view in front of me.

A handsome young black man stopped and spoke with me in English. He said that he was a teacher. I asked him, "What are the people saying?" for the crowd seemed to be in a joyous spirit. "They say they would like to take you home with them to meet their families and serve you dinner."

My painting hand dropped to my lap as I pondered the meaning of their words. I had come to Tenwek Hospital to share my skills, but these gracious people were teaching me a lesson in acceptance and hospitality.

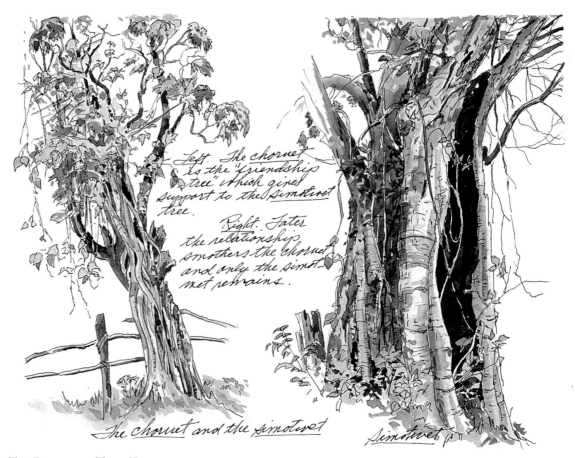

Left. The choruet is the "friendship tree" which gives support to the simotwet tree.

Right. Later the relationship smothers the choruet and only the simotwet remains.

The choruet and the simotwet

Simotwet

THE FRIENDSHIP TREE, KENYA

In Kenya the choruet is called the friendship tree. The simotwet needs a friend for support. Birds and the wind scatter the seeds of the simotwet tree. Some find a home in the bark of the choruet tree, which provides a safe hiding place for the seed. As the young simotwet matures it sends vine-like roots down and around the trunk of the choruet tree. For a while it is a symbiotic relationship but eventually the friendship smothers the choruet. The choruet dies from the relationship and decays from the inside-out. Only the simotwet remains, concealing a hollow core where animals take up residency.

I painted two of these specimens in different stages. While I was working on the second, Henry, a patriarch of the Kipsigis tribe, came over the hill with his five-year-old granddaughter, Sandra, carrying a straw basket. They had brought a thermos of hot chai for me. After pouring the chai into a clean enameled cup, Henry asked Sandra to pray. Their humble and gentle spirits touched my heart. By the time I finished my work I had received two dinner invitations from my gallery of spectators. I hated to decline them but my wife, Marlene, was expecting me home soon.

Arctic Mushrooms, Nunligran, Siberia

While staying in Nunligran, Siberia, my new Eskimo friends invited me on a mushroom hunt. In this cold and desolate land one places great importance in friendships and simple pleasures. They taught me which mushrooms to pick and those that could make me deathly ill. It didn't take long to catch on to this sport.

I was invited to the modest home of one of the villagers for dinner. Food is scarce in this land—you either shoot it or catch it. Neighbors brought in small servings of fresh, uncooked whale meat while others fried crepe-like blinis and sautéed our mushrooms on a small hot plate in the tiny kitchen. The evening was delightful. When I finally said my last good-bye to my Eskimo friends, I realized the lateness of the hour, having been deceived by the Russian "white nights" and a sun that refused to quit.

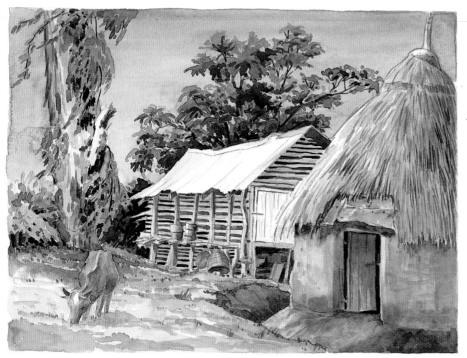

Agness's Shamba, Kenya

My African dental assistant, Emily, and I walked about four miles to visit Agness and her family. Emily and Agness are best friends and work together at the hospital. Agness's **shamba**, or farm, is on the other side of the mountain at the bottom of a deep ravine, cloistered by eucalyptus and acacia trees. It is a lovely place.

Agness heard that I like chapatis, a fried bread similar to tortillas. From the cooking hut she brought stacks of steaming chapatis, which I devoured. Later she ceremoniously poured the hot chai into clean enamel cups.

I asked the young women if their people at the hospital had a nickname for me, the white dentist. They giggled and said, "Yes, we call you 'Marindany'. It means, 'the one who likes everything.'" That's quite a compliment.

It was raining hard when it was time to leave for home. The steep footpath that leads out of the hidden valley was slippery and badly rutted by centuries of erosion. Agness and her fiancé walked with us the two miles to the beginning of the tarmac road that leads to the hospital; it would have been a breach of etiquette not to do so. As we walked the remaining two miles alone, I thought of Agness making her difficult way home in the drizzle and darkness and her gift of hospitality.

WOODWORKING: PAINTING WOOD

You don't have to be a carpenter to paint beautiful wooden objects. However, learning to draw and paint wood will greatly enhance your pictures. Many painting subjects contain something made of wood. You may paint weathered siding, fences, trees, boards or furniture. There is a fundamental technique for painting wood that can be adapted to most subjects. Time spent practicing this art will pay dividends time and time again.

You should always begin with careful observation. See how the light falls on the subject. Does it create form shadows and cast shadows? Do round, wooden objects demonstrate changing values as the surface turns? What else can you see? Can you see the direction of the woodscutter's saw in the surface of the board fence? Is the grain smooth and consistent, or does it meander around the knotholes? How is the wood used or applied? Are there visible screws or nails? Is there staining of the wood created by old, rusting nails? Once you have sharpened your senses you will be ready to begin.

Painting wood, like painting watery reflections, is one of the easiest and most enjoyable techniques of watercolor painting. The following demonstration illustrates two different, yet related, wood subjects: a rotting tree stump and a board fence. When confronted with a wooden subject you are sure to be successful by following these three steps: 1) the basic washes of wood tones, 2) the placement of shadows to create depth, and 3) the detailing of the the grain, knots and any imperfections. Practice these principles on scraps of paper before trying them on your finished painting to overcome any feelings of intimidation and indecisiveness later.

1 Building the Fence

Lightly sketch the scene with pencil. Block in some of the areas with basic, underlying washes. Create the sky by puddling in Cobalt Blue; leave some areas of white to indicate cloud forms. Paint each board of the fence individually with clear water and drop in areas of both warm and cool pigments to create a weathered, dry appearance. Cerulean Blue and Davy's Gray are good for the cool pigments, while Burnt Sienna and Sepia work well for the darker, warmer tones. Change the value and color temperature slightly with different boards to prevent them from looking alike.

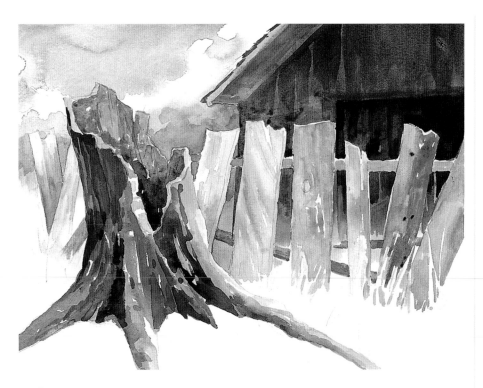

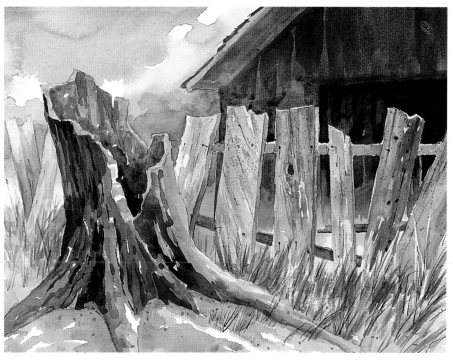

2 Don't Let This Stump You

Take your no. 6 or 8 round and charge it with Burnt Sienna to begin the tree stump. Model the form with Sepia or Neutral Tint, allowing some paper to show through. Now paint the building in the background. Use a mixture of Burnt Sienna and Alizarin Crimson with either a no. 8 round or 1-inch (25mm) flat to develop the form. Reduce the intensity of the building as it nears the ground.

3 Weathering the Wood

Develop the character of the wood by painting over the boards to show variations in the grain and marks left from being ripsawed. Drybrush Sepia, Burnt Sienna and Payne's Gray over the flat boards to create the woodgrain effect using the no. 6 round. Add knotholes, nails and other imperfections. Add Neutral Tint or Sepia in the areas of shadow of the tree trunk to define the bark. Finish by painting the foreground soil and dried grass next to the fence.

Unfriendly Receptions

I rarely meet with any form of hostility on my world travels. But hostility can take many different forms. Undoubtedly the most common threat is that of dogs that jealously guard their space. In some countries this can be a very real danger due to the lack of universal rabies control. I have witnessed a victim in the late stages of rabies, or hydrophobia. Once symptoms of the disease are manifested, the victim is doomed to a horrible and tormented death.

The Cathedral in Messina, Sicily

The harbor boulevard at dockside is chocked with speeding Vespas and noonday traffic. I walked toward the city center in search of a subject to paint. Men seated on park benches halted their conversations, their penetrating eyes following my every step. I felt uncomfortable in this city.

I began to paint the cathedral while sitting on a park bench on the edge of a charming square. There were others in the park around me. People began to slowly migrate toward me. They couldn't resist the temptation to see what I was doing. Reserved at first, the Sicilians began to warm to me, smiling and periodically giving me the thumbs-up sign. They stayed and watched every step until the painting was complete.

When I finished, I walked over to an old woman dressed all in black who was sitting nearby. I shook her hand and wished her a good day. She thanked me for painting their cathedral and extended a blessing to me as I left. The experience taught me that friendships sometimes must be earned. I misinterpreted the Sicilians' intense scrutiny of me for suspicion and hostility. Art proved to be the touchstone for our international friendship.

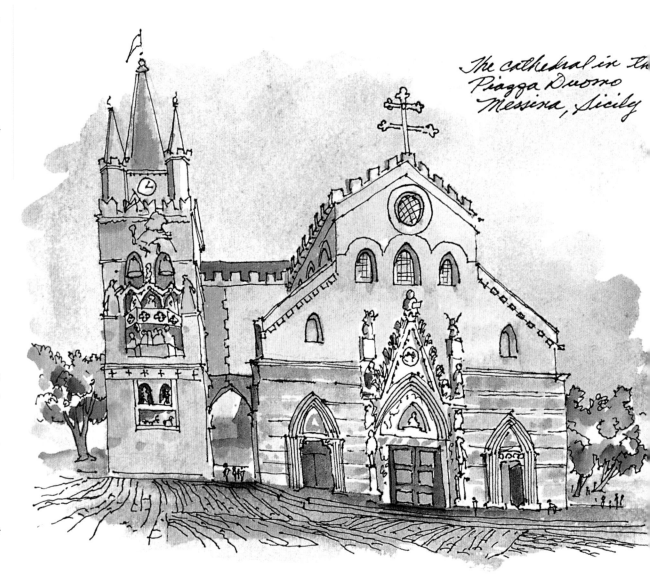

The cathedral in the Piazza Duomo Messina, Sicily

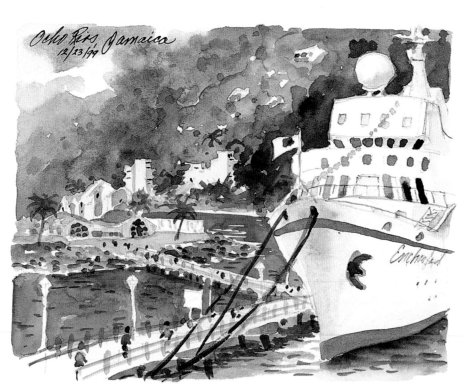

Ocho Rios, Jamaica
12/23/99

DANGER IN PARADISE

I was surveying the beach of this Caribbean island for a possible painting subject when I spotted this idyllic sandy beach with native dug-out canoes overturned under bending palm trees— the perfect composition. After some exploring I discovered a jungle path that led down the hill into a secluded beach. Suddenly I was quickly accosted by a couple of young men and realized that I had walked into unexpected trouble. They wanted money. I explained that I was only an artist and turned all of my pockets inside-out, and the threatening men released me.

My lesson: Use common sense when venturing into unknown territory. Never explore alone or carry valuables. Always leave detailed information where you are going and carry some form of identification.

NORAH'S SHAMBA

I am fascinated by the artistic possibilities of this little farm. Twice, I was chased off the property by the farm dog. Finally, I returned when Norah was at home. She assured the dog I was OK and I was able to complete my painting unchallenged.

Ambassador With Portfolio (Art, That Is)

A visitor to a strange land is always under scrutiny. One's words, and even subtle expressions, are being studied and searched for hidden meaning.

I have traveled to several countries as a volunteer with World Medical Missions, Inc. On these missions, I find myself a reluctant ambassador of sorts. I go to relieve some pain and suffering, but painting in public places opens additional doors to friendly discourse and better understanding. I believe my desire to paint pictures of their country often breaks down relational barriers.

Matigo Hilltop

MATIGO HILLTOP

After Sunday dinner five, of us from the hospital climbed to the highest point in the region to survey the beautiful countryside. This used to be the site of the ancient Kapkoros, but today is marked by the Christian Cross and is still considered holy ground.

ANDRE

The director of the Cultural House of Provideniya, Russia, introduced me to a struggling young artist named Andre. We went into the mountains to paint together on the tundra. Andre did not speak English and our discourse was limited to pointing and animated gestures. Still, we communicated reasonably well, sharing a common bond—the love of watercolor. We could have painted all day but knew it was time to quit when the water started freezing on our paper.

The new road to Chaplino, 9/17/96

JOURNAL NOTE

Graduation Day at Empaash

This was like no other graduation! Jonathan Steury, director of community health, invited me to attend a commissioning ceremony for his first class of fifteen Maasai volunteer Health Helpers near the small settlement of Naikarra, Kenya.

We spent the night at Naikarra, a small community health station, in the land of the Maasai. The next morning we traveled deeper into Masailand. Jon eventually stopped the vehicle where a number of people had gathered in the shade of a solitary fig tree. This was Empaash. The Maasai are nomadic herdsmen, and I should not have been surprised that there was no traditional village.

The graduating class consisted of twelve young women adorned with an abundance of beaded necklaces and bracelets. Their pierced and stretched ear lobes were artistically wound with strands of yellow, red and black beads. Clean red-and-white-patterned kangas and scarves accentuated the loveliness of their ebony features and closely shaved heads. The three male volunteers traded their traditional red togas that day for western-style suits and ties. As I entered the group I greeted each one and shook his or her hand. They were a proud and handsome people.

The chief, as well as other elders, addressed the group, which by this time had grown to more than a hundred people. Songs were sung and scripture was read. Although not a religious event, their faith was an essential, integrated component of their lives. The graduates received their diplomas and were given wind-up tape players—no batteries needed. The helpers could not read and much of the health and hygiene instruction had been recorded in their own Maa language and loaded on the device for future reference.

While the ceremony was conducted, other women had roasted a goat and prepared native food. Jon and I were treated as special guests. In the few hours that I had been at Empaash, the gracious Maasai had treated me as an ambassador with portfolio.

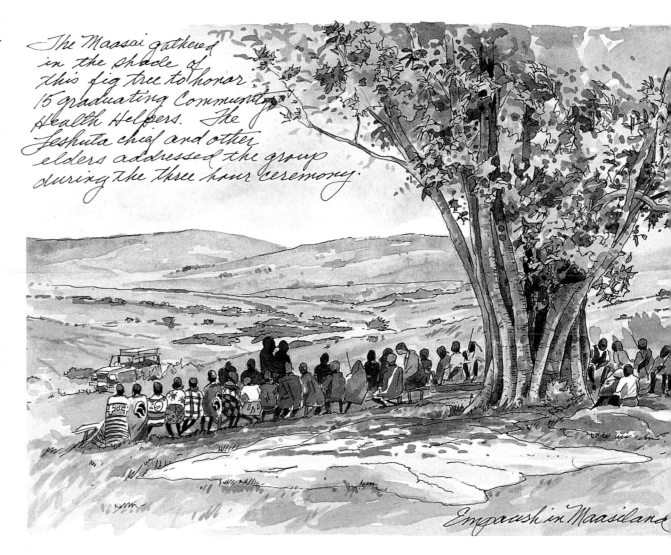

The Maasai gathered in the shade of this fig tree to honor 15 graduating Community Health Helpers. The Leshuta chief and other elders addressed the group during the three hour ceremony.

Empaash in Maasiland

Friendly Encounters

The gift of new friendships has been my greatest joy as a result of my watercolor journeys. I cannot quite identify it, yet there is something about art that connects human spirits and lays low their defenses. I see it happen almost every day that I paint outdoors. People stop to visit with me, while in other circumstances they are reticent to risk openness.

I was working as a volunteer in a dusty village in Honduras. During a rest break I sat on the front porch of a village store and sketched the bodega across the road. Four young men were hanging out in front of the store. When they realized that I was sketching them they glared at me menacingly and crossed to my side to see what I was doing.

I smiled as I handed them my sketchbook. Then I asked if each one of them would sign their names below their images in my picture. They laughed and kidded each other as they took their turns writing their names.

A Birthday Celebration

Another depressing day of wind, sleet and rain in the Siberian Arctic—the only difference being it was my birthday, and I was alone. At 5:00 PM there was a knock on the outer door of the barracks. I could hear women singing outside. As I opened the door the Eskimo revelers filed into the building carrying gifts—flowers, cards, home-preserved blueberry jam and a decorated birthday cake. Where did they find ingredients for such a creation? My personal food supply had dwindled to one remaining orange and an apple. I divided the fruit into sections and shared them with my guests. In this harsh existence, fruit is a rare delicacy. There would be no food for tomorrow, but that night, we partied!

...FOR WHATEVER A MAN SOWS, THIS HE WILL ALSO REAP.—GALATIANS 6:7

Two brothers had spent three months constructing this new mud hut. They were very proud of their work. They offered hospitality to friends and strangers alike—including me during a sudden rainstorm.

On Good Friday 1994, the cooking fire got out of control and ignited the thatched roof. The dry grass of the roof quickly spread the fire and the hut was consumed in flames.

The community returned the brothers' hospitality with gifts of money and helping hands to rebuild the hut. The brothers' kindness was repaid to them in full.

Август 4, 1997

Joseph's Shamba

This is the view from my friend Joseph's shamba. The Tenwek Hospital buildings can be seen on the hill to the right. I spent many Saturdays with Joseph and his family. The children proved to be willing artist's models and there was always a steaming kettle of chai tea on the fire.

As I finished painting the picture of the hospital, Joseph pointed to an ominous-looking, dark cloud hanging over the far hills. Joseph said, "You run fast or you get wet." Unfortunately, I didn't run the mile and a half back to the hospital fast enough.

Golden Olympiade Taverna in Rhodes

A waiter from the Golden Olympiade spotted me in what appeared to be suspicious activity across the street. His curiosity caused him to investigate. He was surprised to find I was painting a picture of his taverna and he became silently engrossed in my activity. Every few minutes he would take leave of his duties to see the progress of the painting. I explained that I would enjoy having lunch in his restaurant. Although it was the busy lunch hour, my new friend kept the best table open for me until I could finish the painting.

While I sipped my retsina wine, the waiter proudly carried the picture around for all of his friends to see. Maybe it was the retsina, but I felt strangely warmed by a friendship that did not depend on the spoken word for mutual respect.

Journal note

Sunday Afternoon in Rural Kenya

I decided to visit my friend, Joseph and his family, who live on a hillside shamba. His wife, Emily, her mother-in-law and six children excitedly gathered around to lead me into their modest mud hut. While a seasonal monsoon began to pelt the grass-roofed home, Emily was determined to milk her solitary cow for the fresh milk that would be used to brew chai on the open fire.

Thankfully I had brought the Magic Slate that my wife, Marlene, had purchased as a gift for the children. It would entertain us for a while since it did not look as though the storm would end quickly.

While the chai steamed on the fire, the children and I took turns drawing simple pictures on the slate. We wrote and taught each other words like cat and dog in our native languages. Tiring of that game I began to draw a picture of the grandmother dressed in her traditional clothing, taking care to show her stretched, pierced ear lobes. The old woman seemed pleased with her portrait.

I turned the Magic Slate to the woman and motioned for her now to draw my own picture. She waved her arms in refusal but the temptation of the drawing stick was too much. Soon, she was totally engrossed in creating my portrait. Her drawing was more diagrammatic than realistic—like that of a four-year-old child. I noticed that she had drawn appendages to my head and I asked if these were my arms. No, was her emphatic answer as she pointed to her long, pierced ear lobes that almost brushed her shoulders, a cultural custom practiced by both men and women. I was startled! Had she accepted me as one of her own people?

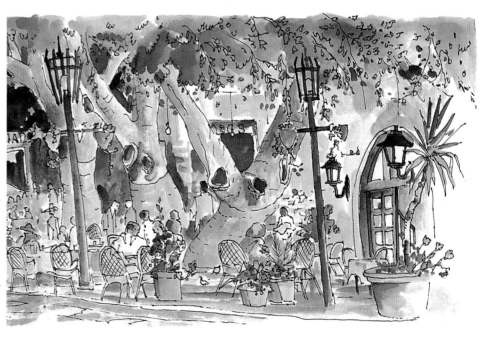

I live in a small city along the front range of the Colorado Rocky Mountains. There are beautiful vistas with ever-changing weather and cloud formations—plenty of inspirational scenes to paint. Many of my favorite subjects are a short distance downtown to the Big Thompson River that runs among the cottonwoods and willows, quietly sneaking through the city. I like to go walking along the river where each season suggests a myriad of compositions, reminding me that I don't need to leave my own town to find a lifetime of painting subjects.

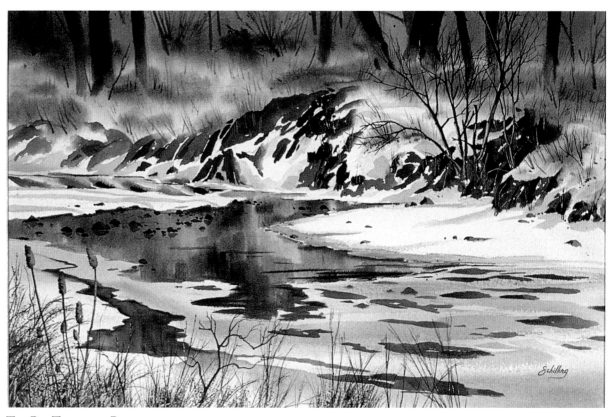

THE BIG THOMPSON RIVER
Beauty can be found in unexpected places. Downstream from this reflecting pool, the river flows under a bridge that carries a frenzy of local commuters unaware of the beauty that flows beneath them. At this time of year the water is running slowly, trickling over rocks and forming pools. Naked trees wait to be clothed in fresh leaves. The perfect time for artistic search and discovery.

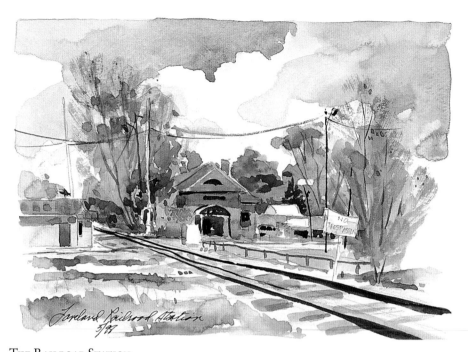

The Railroad Station

The intersection between the railroad tracks and main street is a busy one. The tracks are quiet as only a freight train or two lumber through town each day. The station, modified as a restaurant, has a steady stream of patrons.

The Feed and Grain Elevator

When I turn my back to the railroad station I face the old grain elevator. A hundred years ago there was a steady stream of wagons coming and going. Today, only the pigeons are active. Occasionally a pick-up truck stops for some seed corn or a bag of fertilizer.

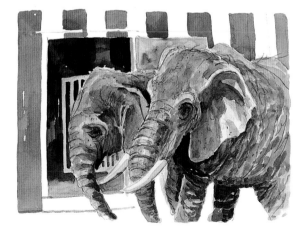

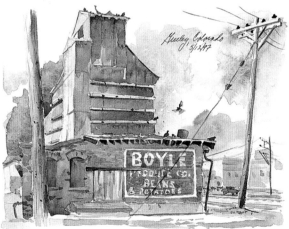

The Circus

The circus comes to town once a year. The best time to sketch the animals is early in the morning before the crowds arrive. There is a flurry of activity as the tents go up and the animals are fed and watered.

In Town

This close-up of the grain elevator was painted while I waited for my car to be serviced. Notice the number of action lines—the vertical telephone posts and the horizontal lines of the grain elevator's siding and roof. The commercial and traffic signs improve the design and add interest.

81

Artistic License

I consider myself a landscape artist. Still, I try to connect with the viewer by including living things that not only add interest but also bring life to my pictures. I believe the common denominator for most of us is an interest in people, especially children, and animals. I attempt to include them in paintings whenever possible. They need not be a prominent part of the composition but are best when they demonstrate action or are engaged in some activity.

Commercial signs and traffic directions also add interest. They indicate the presence of people who are not in the picture. There is a certain freshness when the signs are not totally legible. Carefully measured letters and signs take away from the spontaneity of a quick sketch.

Artistic license should be used to add signs of life that are missing from your paintings. They may simply be symbols created to imitate people or animals. Anatomical accuracy is unnecessary.

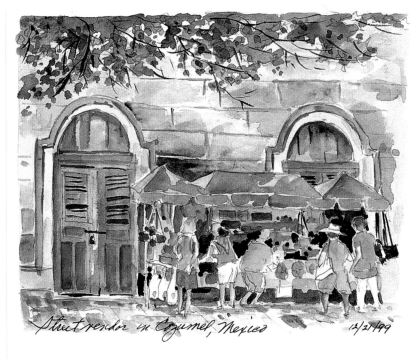

Street vendor in Cozumel, Mexico *12/21/99*

The Market
This sketch was hastily made while standing in the street of a Mexican village. You can sense the shoppers' excitement. It's unnecessary to paint the merchandise in detail when a few brushstrokes can create the suggestion of hanging purses.

A Honduran Home
These chickens add interest and balance to this composition. They indicate signs of life and evidence that the home is inhabited.

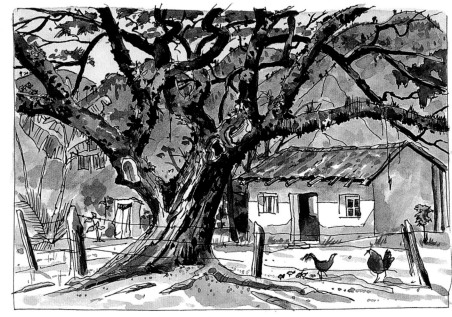

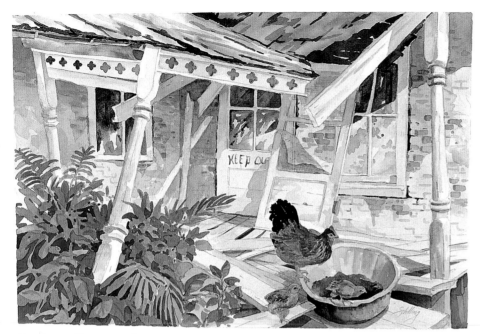

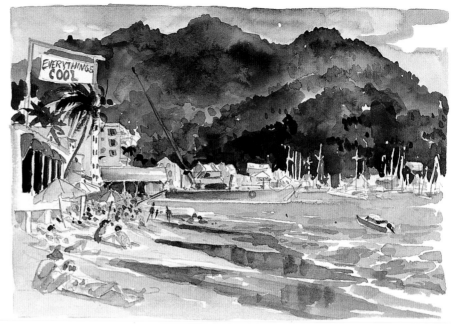

For Sale, Handyman's Delight

I added the hen and her chicks to this dilapidated and deserted dwelling. The chicks express hope and renewal of life. The painting would be meaningless without them.

Autumn Color

The pastoral scene of changing colors from a variety of different trees on the McKensie River's bend was finished with a few strokes of the brush creating the symbols for grazing cattle that added life to the sketch.

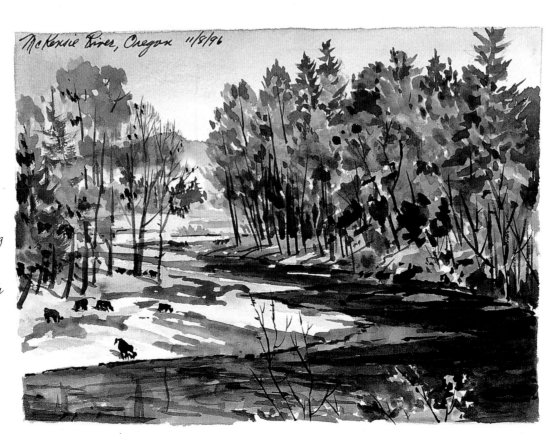

Everything's Cool in St. Maarten

I suggested the bathers on the beach with a few rapid strokes of the brush. The sign adds a whimsical theme to the picture. A smaller sign below smugly points out the day's temperature in Chicago — 15 degrees.

Capturing Life

A blooming flower is a gift to be painted. Pull up a stool and paint a close-up of a single bud or flower bloom. Your efforts will be rewarded. Time spent painting is never wasted; each effort is a learning experience. I like to arrange kitchen utensils and bottles in still-life compositions. You can find an infinite number of subjects inside your cabinets. Fresh fruits and vegetables can be enjoyed twice— both as delicious produce and as painted subjects.

I use the still-life motif to record and illustrate cultural, botanical and entomology subjects. They add important information to my journal. Often, these ideas are left for days of inclement weather when it is impossible to paint outdoors.

When you are at a loss for subjects to paint, create your own by setting up an arrangement of plants or objects. Here are some of the many still lifes I have painted.

AFRICAN HIBISCUS
Everything grows larger in the highlands of Kenya. I picked a couple of blossoms and added some wild roses to the vase. The slash of intense dark value sets off the floral portrait.

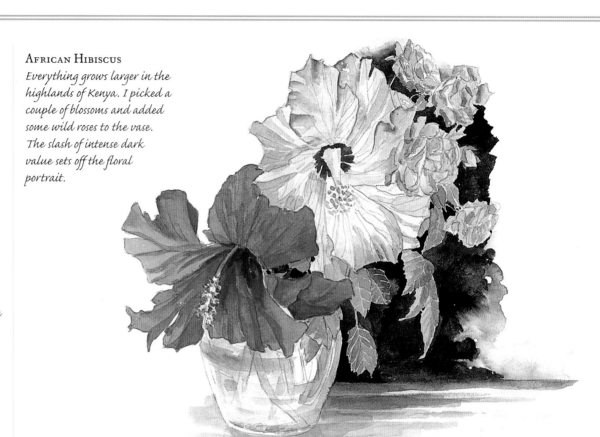

VEGETABLE STILL LIFE
Delicious fruits and vegetables are abundant in western Kenya. Blessed with a combination of good soil, adequate rainfall and a twelve-month growing season, the Kenyans are able to produce enough food during most years for the burgeoning population.

The western highlands is the garden spot of Kenya

The Flissigen No. 8

This was an especially long crossing of the Atlantic Ocean and I was at a loss for things to paint. I found this model of a well-known Dutch schooner on board my ship. It provided a fascinating subject and a pictorial record of a historically important sailing vessel.

The Fruit of Life

As I walked a path in Kenya, I noticed a child in the branches of a tree. As he shook the branches, his older sister gathered up the ripe loquats as they fell to the ground. I asked them if they would share them with me as I wanted to paint a portrait of the fruit.

Flowers of the Maasdam

This table arrangement provided me hours of entertainment. Flowers, even a solitary bloom, are subjects of great beauty for the artist. Each effort is a learning experience for me. I am awed by the miracle of each bloom.

People at Work

I like painting people at work. Working people are not concerned with your activity and don't have time for any contrived poses. It seems to me that the greater number of people around you, the less attention is drawn to you and your work, which is somewhat comforting. Once you shed your public self-consciousness and begin to cover the blank paper, you gain momentum and energy.

If you're sketching people in action, do a stop-frame mental image of the action of one person at a time. Don't worry about creating an exact likeness of the individual. Look for the action in the figure, the task that is under way and transfer this energy to the paper. We often recognize friends and family at a distance not by their facial characteristics but by the way they walk and carry themselves. As you continue to lose your inhibitions, your sketching style will increase in speed and accuracy.

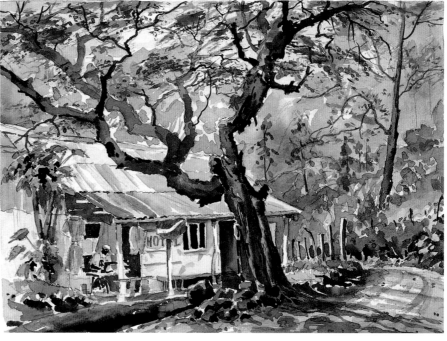

MAKE WORKERS YOUR FOCAL POINT

Gervas, the tailor, lives in Africa. He works at his trade using an antique, foot-powered sewing machine. Without him working his craft, this picture would have been an uninteresting landscape. Adding people to your landscapes creates an instant focal point in your painting.

PICK YOUR SUBJECTS CAREFULLY

I was invited to Agness' shamba for lunch. After we dined, I asked the family if they would teach me how to pick tea leaves. Only the top two, tender leaves and the bud are picked. I was amazed at the speed with which the pickers worked. This ordinary task became the subject matter for my painting and the perfect recording of my day at the shamba.

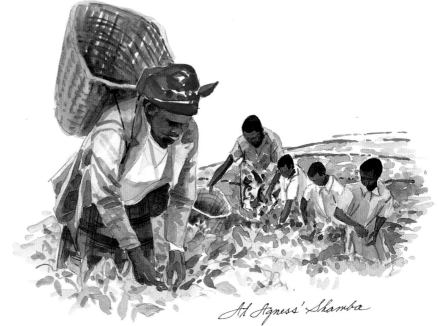

At Agness' Shamba

Dinner Is Served

I asked permission to record the activity on a cruise ship behind the dining room's swinging doors. The chef was pleased that I had asked and provided me with a work area and comfortable chair. The men worked over polished, stainless steel counters and serving carts. When the sketch was finished I added a cool wash to define the equipment and fleshtones to the faces of the workers.

Observing The Pilot Room

*The six and one-half hour crossing of Lake Superior on the vessel **Ranger III** prepared my body, mind and spirit for the adventure that was to come. Lake Superior is the world's largest freshwater lake and often generates vicious storms that threaten the Great Lakes' seamen. Isle Royal is surrounded by shipwrecks of less fortunate mariners. The captain invited me to the pilot room of the **Ranger III**. I found an out-of-the-way spot from which I observed the activity on the bridge.*

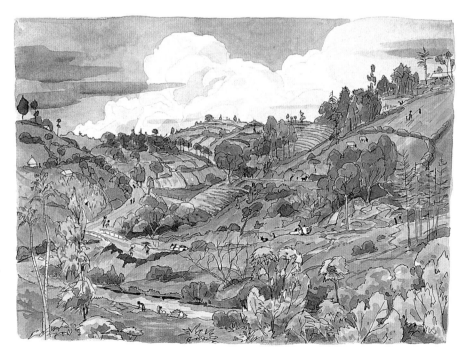

Capturing Many Activities At Once

From the porch of my modest highlands home I could view a panorama of activity occurring on the opposite hillside. The chores were all visible at the same time: boys herding cows, women washing clothes by the river, overloaded matatus (pickup truck-taxis) and people walking to the nearby village. Later, all activity quickly came to a stop as the president of Kenya and his entourage paid an unexpected visit to the community.

Calling All Ships at Sea!

Since boyhood the sea has always tugged at my heart even though I grew up far away from the coast. I built wooden boats to sail in a nearby pond, dreaming of ocean crossings. I loved reading the accounts of the early explorers, the diaries of polar expeditions and classic, nautical literature—**Moby Dick** and **Two Years Before the Mast** were two of my favorites.

Now as a ship's dentist I am able to fulfill my fantasies of sailing to faraway places and painting pictures during shore leave. Not only are the ships themselves perfect subjects for sketching, but they also provide an excellent perspective from which to paint port cities and surrounding countrysides. Painting from the top deck gives me a view and elevation that is about a hundred feet above the water, creating an unobstructed view for miles around.

I am so fortunate to be able to paint my passion. When you are able to paint what you love, you build a treasury of unforgettable memories. Remember this when selecting your subject matter.

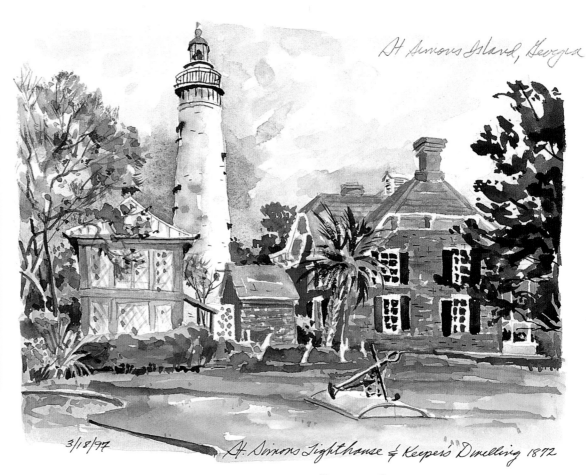

St. Simons Island, Georgia

3/18/97 St. Simons Lighthouse & Keeper's Dwelling 1872

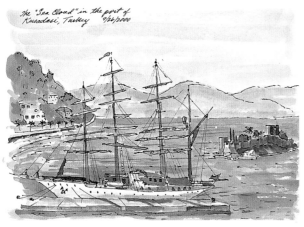

The "Sea Cloud" in the port of Kusadasi, Turkey 9/26/2000

THE SEA CLOUD SAILING SHIP AT KUSADASI, TURKEY
This gleaming white sailing ship tied up next to us in the Aegean Sea port city of Kusadasi. The crew and passengers were visiting the nearby, ancient city of Ephesus.

BEACON OF SAFETY
The lighthouse on the southern end of St. Simon's island is a beacon of safety for ships returning home and those in the shipping channel nearby. The lighthouse keeper lives in the red brick building next to the lighthouse. Buildings such as lighthouses create a tie to the land in your paintings and are great additions to your nautical artwork.

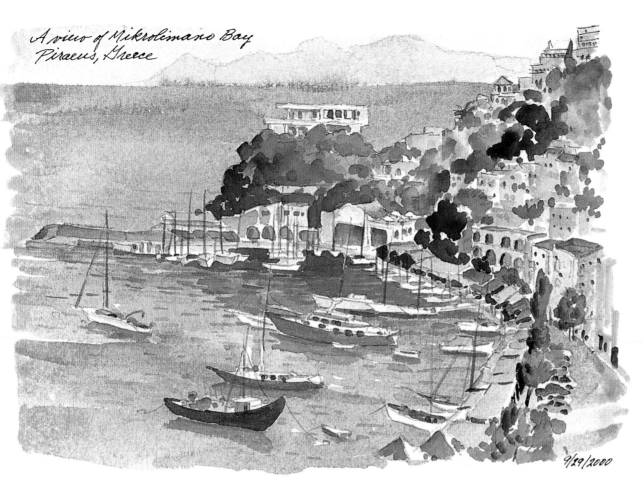

A view of Mikrolimano Bay
Piraeus, Greece

9/29/2000

THE S.S. RYNDAM IN JUNEAU

It is not always necessary to paint the entirety of a ship, or any other subject, if painting just a segment can tell the story. This painting captures the beauty and massiveness of the ship up close. The vertical lines of the pier help the design, and the reflections on the boardwalk tell us that it has been raining.

MIKROLIMANO BAY AT PIRAEUS, GREECE

I disembarked my ship in Piraeus, Greece after circumnavigating the European continent. I made this painting from the balcony of my room the night before returning to the United States. The harbor shows boats, buildings and the acute hills of this Grecian city.

Hyde St. Pier
San Francisco
9/29/98

THE BALCLUTHA AT THE HYDE STREET PIER

A port call in San Francisco provided a leisurely day on the waterfront. I sat on a park bench beneath spreading branches to paint this historic sailing ship. The square-rigged vessel was built in Glasgow, Scotland in 1886 and carried grain around Cape Horn.

A Walk in the Park

Parks present endless opportunities for paintings: strolling families with active children, abundant flowers, trees, monuments and statues. They are perfect places for creating a watercolor painting or gesture drawing. This is the art of capturing the motion and attitude of human forms in a few well-executed strokes of a pencil or drawing pen. One-minute gesture drawings will help you develop an eye for recording the energy and motion of your subjects with an economy of effort and detail.

BE SENSITIVE TO YOUR SURROUNDINGS
I search for the more restful subjects, away from vendors, in plazas and parks of cities and villages. Life in Acapulco, Mexico, is at a slower pace. While I paint, my ears become more sensitive to the sounds of children playing nearby and native songbirds singing unfamiliar tunes. They enrich my experience and, hopefully, my art.

PERSPECTIVE IN PLAZA SAN MARTIN, BUENOS AIRES
Painting the downhill perspective of this park was a challenge. I placed small figures walking along the path at the bottom of the hill to solve the problem. The day was a success because I spent the afternoon with Argentinians enjoying their park.

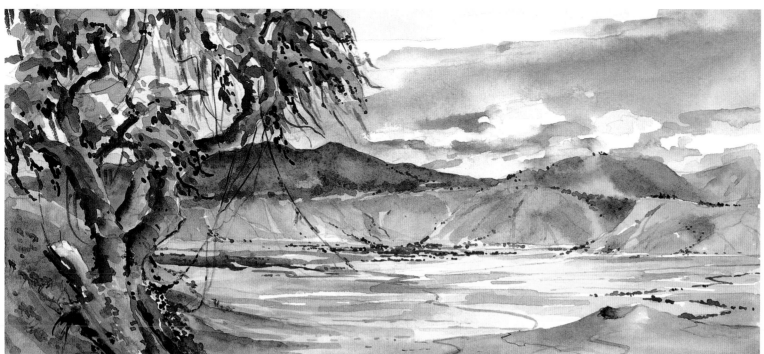

THE NGORONGORO CRATER IN TANZANIA

This a different kind of a park. The caldera forms a delicate ecosystem of diverse wildlife. It measures eleven miles across with a rim rising 2000 feet to an elevation of 7216 feet. Professor Bernhard Grzimek has called it one of the wonders of the world.

HAAVIS AMANDA IN HELSINKI

I strolled this lovely park on a Sunday afternoon. Flowers were profusely blooming and sunlight shimmered through a canopy of leaves. The scene had everything that I desired, including a park bench conveniently placed for my comfort. The buildings, flowers and trees are only implied, but they give the right impression. Eliminating detail can create the right atmosphere for parks and other natural settings.

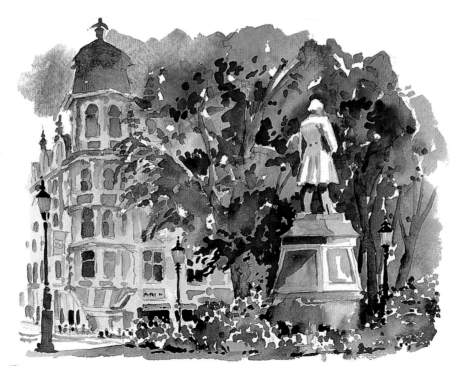

I had seen a herd of elephant traveling through dense native forest...pacing along as if they had an appointment at the end of the earth.

—Isak Dinesen (Karen Blixen), *Out of Africa*

People Pleasers: Finding Suitable Models

Portraits and character sketches add interest and insight to your journals. I find that most people are willing to be models. It is my custom to carry a pocket full of American dollar coins to reward my sitters. After completing a drawing, I copy their names and addresses in my sketchbook and send them a color copy of their portrait. This has sparked more than one continuing friendship.

WELCOME TO PUERTO VALLARTA!
These musicians warmly greeted me on the dock of this port city. I didn't need to look any further for a subject to paint. While focused on my work, I was unaware that some American dollar coins had fallen from my shallow pocket onto the ground. A Mexican boy picked them up and returned them to me. I rewarded him with half of the coins for his honesty and kindness.

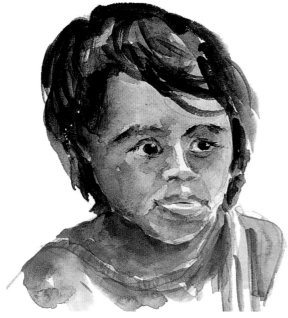

VICTOR AT ACAPULCO
I found a park where children were playing. Some were selling gum, helping their parents scratch out a living. I paid Victor a golden dollar coin to pose for a few minutes. I was halfway into the sketch when I turned my back for only a moment—just long enough for Victor to disappear into the crowd.

THE EVANGELIST
I met this kind gentleman in Honduras. He saved souls by day and entertained by night with his mandolin and bluegrass music.

Mwanaidi

Arusha, Tanzania

JUDY CHEPKOECH

Judy's name means "girl who was born at sunrise." she willingly posed for this portrait among the pink daisies of Joseph's shamba.

MWANAIDI

Occasionally I discover a face that begs to be painted. This young lady served me lunch one day at a hotel in Arusha, Tanzania. she shyly agreed to sit for her portrait when her work had finished. Her natural beauty and ethnic costume were perfect complements to the surrounding bougainvillea.

snow, glaciers and ice fields are some of my favorite subjects. Winter is a magical time for painting. The sun is low in the sky, often creating dynamic purple shadows. I look for dry grasses with tawny shades of color that play hide-and-seek among patches of remaining snow. Trees, naked of their leaves, show their true forms and contrast with skies, soft with pastel shades of blue, pink and rose. I use the long, linear shadows of winter to create sparkling contrast with white, unpainted paper. These contrasting values create crispness in my paintings. Remember there is often a predominance of warm tones in winterscapes. Too much blue can cause an unnaturally cold picture.

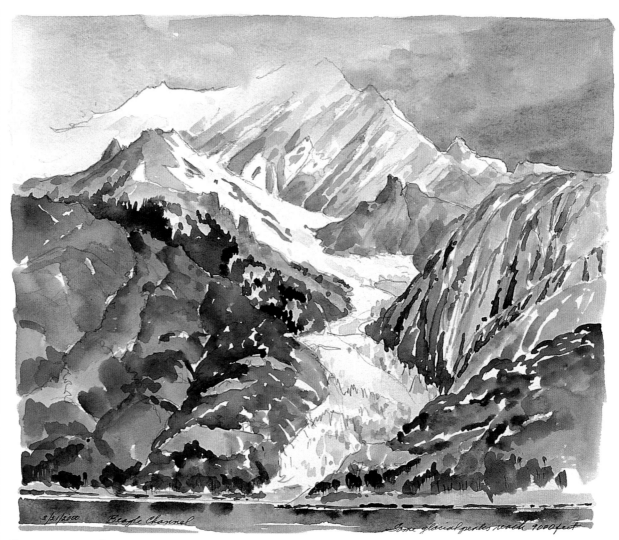

3/21/2000 Beagle Channel *Some glacial peaks reach 9000 feet*

GLACIERS OF THE SOUTHERN ANDES

Some mountains on the Chilean coast tower 9000 feet above the ocean. Frozen rivers of glacial ice tumble down the steep precipices. The blue color of the ice is caused by the tremendous compression of the moving mass. Incredible!

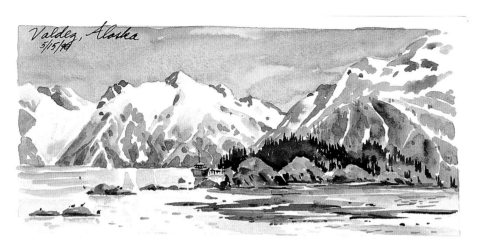

Valdez, Alaska
5/15/99

USING CONTRAST AT THE END OF THE LINE, VALDEZ, ALASKA

Valdez marks the end of the Alaskan pipeline for crude oil that starts its long journey from the North Slope. A low tide in the Prince William Sound presents artistic opportunities to force contrasts: warm against cool colors, lights against darks. In late spring, snow still blankets the mountains all the way to sea level.

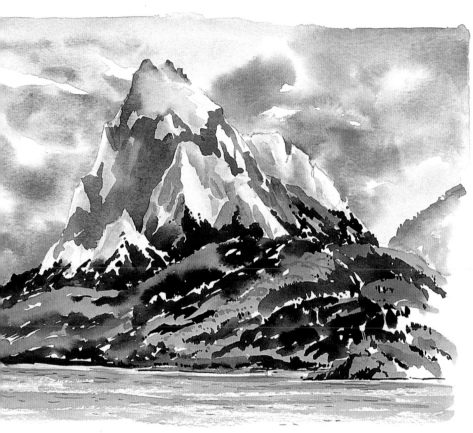

CAPTURING CONTRAST—THE BEAGLE CHANNEL, TIERRA DEL FUEGO, SOUTH AMERICA

I wouldn't have believed it if I hadn't seen it. I thought mountains this steep and surreal only appeared on romanti-cized logos and commercial trademarks. The jagged peaks of these geologically young mountains are a startling contrast to the green vegetation of the coast. This contrast created the perfect subject for a painting.

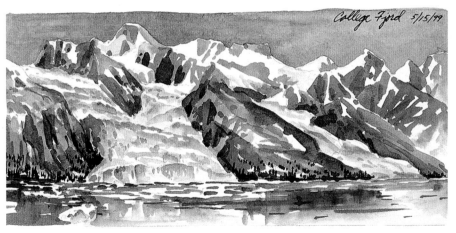

College Fjord 5/15/99

GLACIERS OF THE COLLEGE FJORD

Geologists of the Harriman Alaska Expedition of 1899 named these glaciers for the universi-ties that supported their work. Two of the six calving, tidewater glaciers can be seen in this panoramic sketch. I am reminded that these giant masses are not static when snaps and cracks resound in the narrow bay foretelling of the calving ice. The resulting icebergs create waves that rock the ship.

PAINTING ROCKS: CREATING FORM

Making objects appear round is a constant challenge for the artist and a technique well worth the practice. Painting with watercolor provides the perfect means for expressing rounded surfaces, and the basic rules are quite universal. Rocks, cylinders and other round objects are painted in much the same manner. You can adjust the technique slightly for any rounded shape.

This technique requires the use of three different color values or intensities to create a feeling of depth and dimension. To indicate the texture of the surface, you may wish to stipple the surface or drybrush it with some pigment for the appearance of roughness. Suggest fractures in the rocks with curvilinear lines. Finally, nail down your rocks to prevent them from floating away by indicating their cast shadows. Grass and structures painted in close proximity can help solve this problem. You can modify this same technique to paint wooden objects by simply adding lines to indicate the grain.

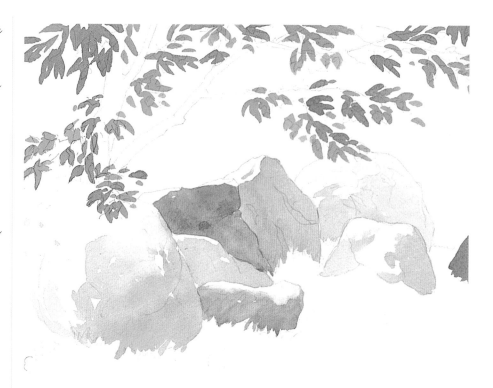

1 Paint the Rocks

Make a light pencil sketch. It is helpful at this point to also make a value sketch of the subject. This will help you place pigments of strength and value in their proper places to emphasize your subject.

At least three value changes are needed to give roundness to an object. Use the white of the paper for the lightest value. Place a medium-valued wash in the form-shaded area of the first rock. Let it dry before painting the adjacent rock. Rocks from different sources will vary in color and texture. Paint the cooler rocks with a no. 6 round using a mixture of Davy's Gray and Cobalt Blue. The sandstone rocks in the center are much warmer, so use a wash of Raw Sienna and Davy's Gray to paint them. Paint a small amount of green on the undersides of the rocks to indicate the reflected light from the grass. Use a no. 6 round to paint the leaves of the alder tree with a thin mixture of Sap Green and Naples Yellow.

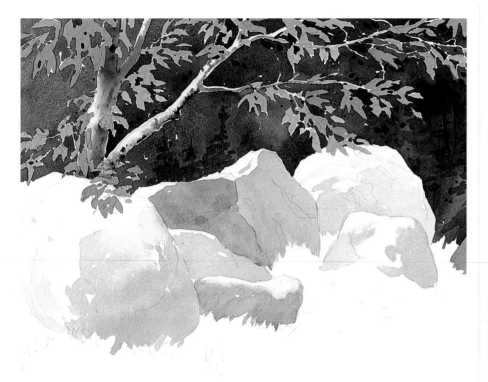

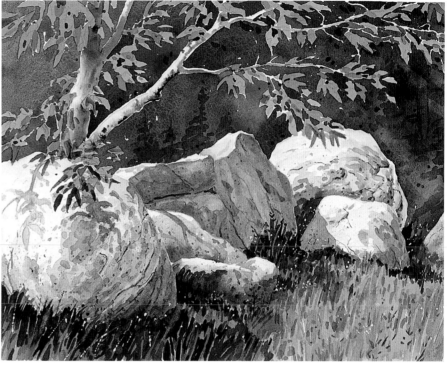

2 Paint the Trees

Wet the tree trunks with clear water. Allow the paper to absorb the water until the surface glistens. Use a no. 6 round to place a mixture of Davy's Gray and Raw Sienna on the shadow side of the trunk and limbs. Allow the pigment to flow toward the sunlit side. Other texture and aberrations of the bark can be suggested by touching the wet shadow side with Payne's Gray or Sepia.

Paint the background with dark values to force the objects in your painting forward. French Ultramarine Blue and Sap Green work well. Allow them to mix on the paper. Start in one of the upper corners and work downward. Never allow the painted edge to dry without adding further paint. This technique allows you to paint around complicated objects without leaving a hard edge.

3 Create Roundness

Create more roundness of the rocks by adding darker values in the form-shadow areas and by wrapping reflected shadows of trees over their curved surfaces. Add texture by drawing a few fracture lines using a no. 4 rigger and speckling the surfaces with other colors.

Finally, anchor the rocks by painting the grass of the foreground. Neutral Tint can be painted over the green to create the darkened shadow areas. Remember that shadows rarely follow straight lines on textured surfaces such as grass.

Mapping the World

When possible, add maps to your sketchbook. They provide the viewer with useful information and identify the location of your work. Maps can be detailed or sketchy depending on the style of your book. Even hidden treasure or whimsical maps are pleasing additions.

Your map may locate a foreign country, a neighborhood park or mark the way to an unforgettable restaurant or fishing hole. For more examples of sketchbook maps, see pages 62, 119 and 120.

CRUX, THE CROSS

The Southern Cross is the common name for the smallest constellation in the sky: Crux, the cross. It appears as a kite lying on its side. The general location of the South Pole can be located by measuring four and one-half lengths of the cross to the right and scanning a plumb line down to the horizon. This diagram illustrates the method.

THE SOUTHERN CROSS

I like to be creative with my map illustrations; the heavens are full of stars waiting to be mapped. As a creature of the Northern Hemisphere, I associate the Southern Cross with romantic adventures of the southern seas. As my ship rounded Cape Horn I was on deck on the first cloudless night to locate this famous constellation.

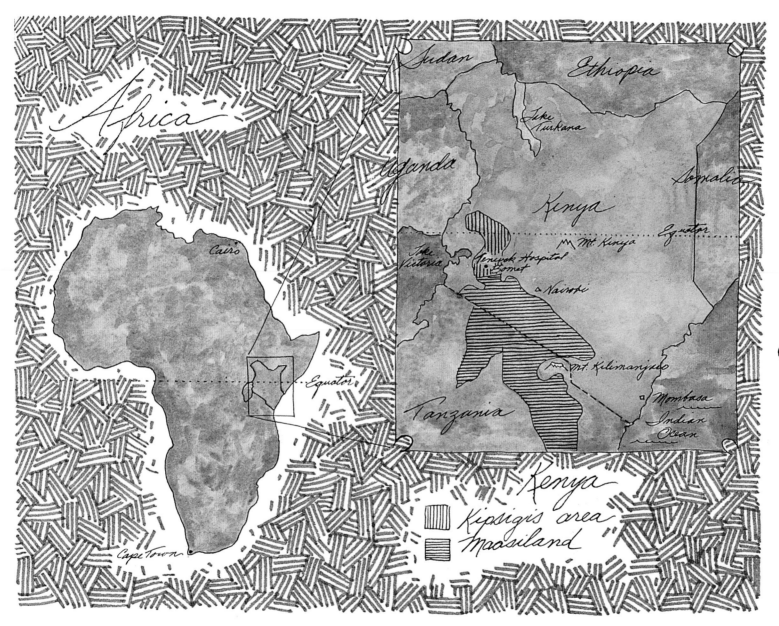

Africa

Cairo

Equator

Cape Town

Kenya
▓ Kipsigis area
▬ Maasiland

Sudan

Ethiopia

Lake
Turkana

Uganda

Somalia

Kenya

Equator

Λ Mt. Kenya

Lake
Victoria

Tenwek Hospital
Kaboson

□ Nairobi

Tanzania

Λ Mt. Kilimanjaro

□ Mombasa

Indian
Ocean

MAPPING THE AFRICAN CONTINENT

I drew the basic shape of the continent of Africa, locating a couple of cities and the Equator. Then I made a blowup of the specific area of the map to identify more landmarks. It's good to keep the map as simple as possible in order to clearly locate the necessary information. Be creative with different patterns, colors and textures to artfully develop the oceans, mountain ranges and deserts.

JOURNAL NOTE

Creating Maps

When working in the field I wait until later to add labels to insure correct spelling and placement. I reserve the last page of my journal for taking notes. Labels are added after I have verified the information and spelling.

KENYA

Painting at Historic Sites

Painting at popular tourist locations and historic sites probably presents the most difficult challenges for an artist. Large crowds and a lack of places from which to paint are the major concerns. Still, the results can be worth the effort. I try to find a unique way of looking at my subject. Typical post-card views painted of familiar sites may lack the emotion you really wish to convey for your subject. Instead, look for a fresh and different perspective to give your viewer new information. This might take the form of an ornate door to an historic building or a portion of a famous fountain.

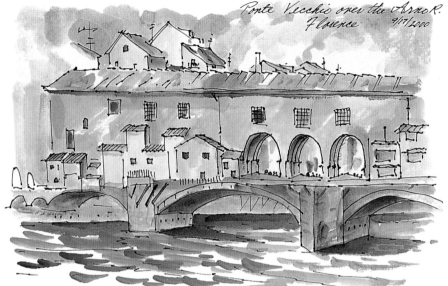

PONTE VECCHIO, FLORENCE

The cement retaining wall of the Arno River absorbs the warmth of the autumn sun, making it a comfortable place to paint. Soon, others took my example and hopped up on the wall to bask in the Italian sun. I don't know who was entertaining whom more. I enjoyed overhearing their animated conversations while they seemed to delight in the progress of my sketch.

FAST SKETCHING AT FONTANA DI TREVI, ROME

Fontana di Trevi is a favorite spot for both young lovers and tourists. You may have to wait for an available seat on the curving cement steps. I attempted a quick sketch with an accenting wash while seated shoulder to shoulder with my Italian companions.

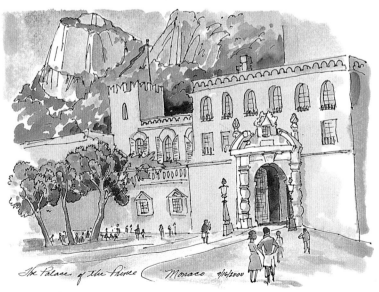

STAY FLEXIBLE

I thought my street curb was a safe and comfortable place to view the Palace of the Prince in Monaco; the morning crowds were light. I was just getting into the sketch when police officers instructed me to move. Preparations were being made for the arrival of the prince and the changing of the guard. After I moved I tried to maintain the original viewing angle and perspective. Being flexible is key to being an artist.

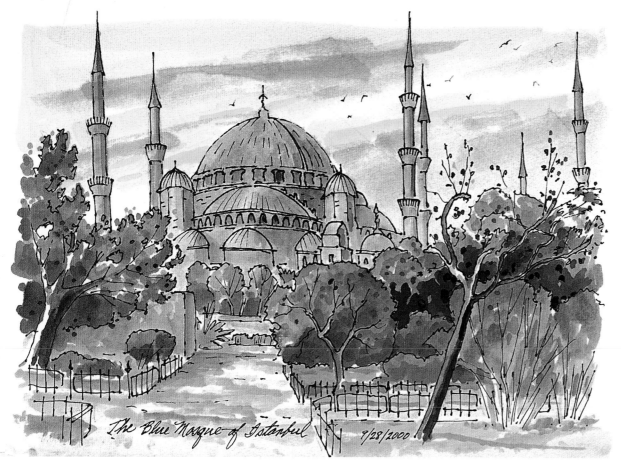

The Blue Mosque of Istanbul 9/28/2000

BLOODY MARSH, SAINT SIMON'S ISLAND, GEORGIA
I like this place. Many historic sites change with the years, but this marsh may look much like it did at the time of a decisive battle in 1742 when the British defeated the Cuban Grenadiers—Spain's best troops.

THE BLUE MOSQUE OF ISTANBUL
It was late afternoon. Suddenly, from towering minarets, the evening call to worship reverberated throughout the city. Black birds took to the sky while the final rays of sunshine danced on the domes of the mosque.

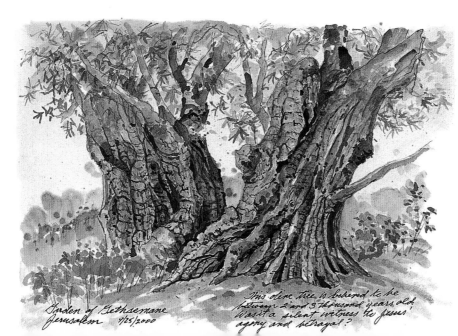

Garden of Gethsemane Jerusalem 9/25/2000

This olive tree is believed to be between 2 and 3 thousand years old. Was it a silent witness to Jesus' agony and betrayal?

GARDEN OF GETHSEMANE, JERUSALEM
The character of these ancient and venerable olive trees capture the spirit of the Garden of Gethsemane. They are between two to three thousand years old.

THE GRAND CANAL OF VENICE: PAINTING WEATHERED BUILDINGS

– SUPPLIES –

Paints
Alizarin Crimson
Cadmium Red - Cobalt Blue
Cerulean Blue - Davy's Gray
Payne's Gray - Raw Sienna
Raw Umber

Brushes
1-inch (25mm) flat
No. 4 round

Many old masters have painted scenes from the Grand Canal of Venice. Now, it's your turn. Try your hand at portraying the character of these old buildings, some of which are a thousand years old. Don't make your lines too straight, for the buildings sometimes tilt as they slowly sink into the swampland on which the city was built. Venice provides the most remarkable array of painting subjects but scarcely a place from which to work. Sidewalks are narrow and jammed with people. If you go to Venice, you may wish to take an extended lunch and paint from the comfort of a sidewalk café.

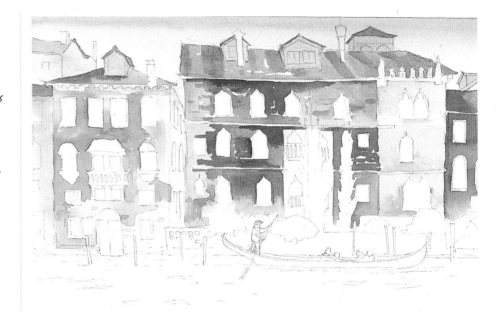

1 Block in the Building Shapes

Complete a drawing with some detail. This is important for the success of this subject. No need for accuracy and plumbed lines; just remember that some of these buildings are a thousand years old and lean naturally.

Cover the paper as quickly as possible with washes. Begin with a gradated wash of Cobalt Blue for the sky using a 1-inch (25mm) flat. Wet the paper with clean water in the area of the upper buildings so your wash will fade out and disappear, leaving no hard lines.

Paint the shapes of the roofs using a mix of Raw Sienna and a small amount of Alizarin Crimson. Paint the dormer windows with Davy's Gray. Paint the building shapes using a different tint for each residence. Use Cerulean Blue for the cool buildings and Raw Sienna, Raw Umber and Alizarin Crimson for the warmer structures. Begin painting each building from one corner, placing paint to the paper and washing out portions of the color to create both hard and soft edges. This will imitate the decaying plaster exterior that exposes some of the underlying brick.

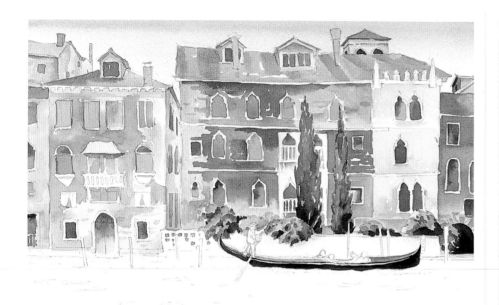

2 Building Construction

Complete the blocking-in process by painting the water with a 1-inch (25mm) flat and a light-valued wash of Davy's Gray. Don't shade or provide detail in the water at this point.

Return to the building facades and block in the window shapes using different pigments to suggest the curtains and shutters of the inside rooms. Don't worry if the windows and doors don't line up. You may wish to change the size and position of windows or even delete one or two to prevent the picture from becoming too rigid or disciplined.

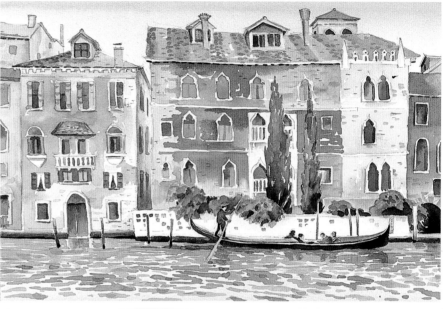

3 Bring the Painting to Life

Adding people will always add interest to your paintings. The gondolier and his fares provide another dimension to the picture. Use a no. 4 round to paint the gondola with Payne's Gray. Then add the figures in the boat. Let the colors blend without defining the clothing. From this distance, you are unable to tell exactly how the people are dressed.

Finish the details of this picture, looking for the manner in which light falls on the subject. Shadow lines within the window casements create a feeling of depth. Place a second and stronger value of Davy's Gray in the water of the canal and add a slight shadow beneath the gondola. The texture and color of the rooftops may need strengthening. Suggest roof tiles using a stronger value of Cadmium Red and Raw Sienna placed judiciously in several areas.

The environment is not always friendly. Plein air painting has its problems and inconveniences. I have been mobbed by small African children, most of whom were suffering with head colds and other viruses. Overly friendly dogs with jumping fleas are always attracted to me. While in Kenya, Penny, a shepherd mix, took it upon herself to be my protector. When anyone approached me, Penny would ferociously send the surprised visitor running and grasping for tree branches with which to defend himself.

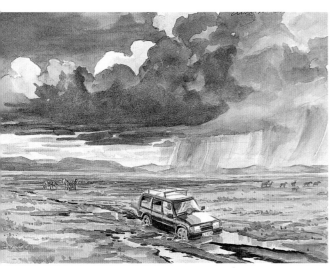

Bogged Down on the Serengeti
Jon and I were returning from three days in the roadless Maasiland when our Land Rover fell into a deep pothole. With no road service to call, we dug and filled the holes to free the vehicle. After that, we were much more watchful to avoid any sign of standing water.

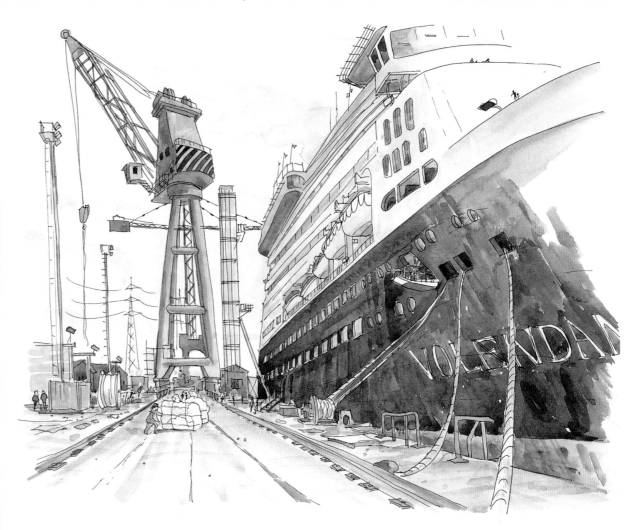

Danger in the Shipyard
The **M.S. Volendam** was nearing completion in a Venice shipyard. Shortly after I finished painting, the cables on this giant crane broke, causing the boom to crash to the ground and killing three shipbuilders.

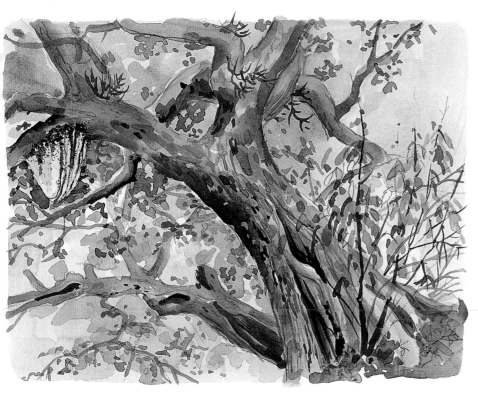

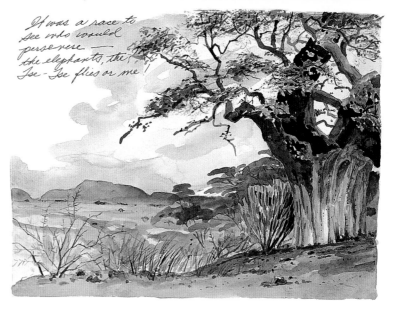

It was a race to see who would persevere — the elephants, the Tse-Tse flies or me!

The Baobab Tree

I sat on a game trail in Tarangire, Tanzania to make this sketch of the strangest tree I have ever seen. The Baobab tree is sometimes called the **upside-down tree** *because most of the year the leafless limbs look more like roots. I worked quickly, as I had seen elephants on this trail earlier in the day and I was anxious to finish my work before being surprised by one of these silent giants.*

Beware of Buzzing Bees

I came upon this huge beehive in a fig tree in the Masai Mara. Fortunately, I was able to sit and work without being attacked by the bees.

On another occasion — my most fearful experience while painting outdoors — I was completely engulfed by a swarm of African bees. At first I thought it was only a sudden wind rustling the trees when the cloud appeared. Hundreds of bees covered my body and began to crawl beneath my clothing. I was really frightened, but to flee would have meant certain disaster. I attempted to distract myself from anxious thoughts by focusing on the drawing I had started. Bees were crawling over my wrists, fingers and drawing paper. Suddenly, without any audible sound, the bees began crawling out of my shirt sleeves and pant legs. Within minutes, the dark cloud disappeared into the woods. I was shaken but survived without harm.

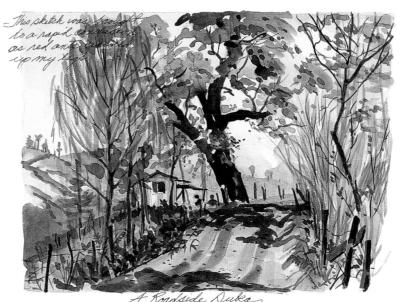

This sketch was brought to a rapid conclusion as red ants crawled up my legs.

A Roadside Duka

Carefully Select Your View Point

A **duka** *is a place to pause and refresh along a dusty road in Africa. They are small, kiosk-like stands selling only a few items and soft drinks. I sat down along the side of this road to sketch. My picture came to a hasty conclusion when red ants started crawling up my ankles. Make careful decisions when selecting the vantage point for your painting.*

105

Discovering Customs and Cultures

I have always had a natural curiosity to learn about the lifestyles of indigenous people. When I spent six months working with the Kipsigis people of Kenya, I learned more about their customs and culture than any other ethnic group I have encountered. I could not have done this on my own; I had two of the best teachers, Daniel Salat, a retired schoolmaster, and Henry Tuei, Daniel's childhood schoolmaster. These tribal patriarchs located botanical specimens and artifacts that were significant in their culture. The two told me stories and taught me traditions from their culture, some of which were not generally known to their own people.

Daniel and Henry encouraged me to document and illustrate their traditional implements, beaded adornments, trees and plants in order to preserve this information for a generation of young people who were drifting away from the traditional ways of their forefathers.

I treasure those experiences and hope that the following pictures will help you look at your own surroundings for creative opportunities to record your family or cultural heritage.

NARIET
Young men in the final stages of their initiation wear a leather crown decorated with cowrie shells.

SEMWET
Beaded jewelry worn by older women is used in the ceremony of peacemaking. The warring parties go to an older woman to borrow her semwet. It is placed on the ground between them and symbolizes to each, "We will carry this no further."

PASSING THROUGH THE GATE
Boys and girls eagerly await the process of rebirth in which they are initiated into adulthood. It is a rigorous and sometimes frightening experience that teaches candidates pride and perpetuates the traditions of the tribe. The final coming out is carried out at the mother's hut. An arch is constructed from a special tree. A small girl stands beside the archway and lifts the gate as the young man, ceremoniously, passes into adulthood wearing the traditional skin coverings and nariet headdress.

A Diagram of a Traditional Kipsigis' Hut

A hut in the Kenya highlands is usually constructed with the help of family or friends. A site is selected that allows for adequate drainage of the seasonal torrential rains. An effort is made to keep the entrance door on the higher side of the hill, facing north or northeast. It is imperative that the **mabwaita**, the family altar tree, is placed to the right of the door and just east of the home.

The supporting walls and roof are constructed of very strong limbs and branches. Dried grass is bound together for thatching and tied into the ridge poles of the roof. The vertical supports are woven with smaller branches into wattle, which forms the matrix of smooth, mud-plastered walls. The roof is capped with a single vertical spire that expresses the homeowner's individuality.

The following is a key to the cut-away drawing of the Kipsigis' hut. The open room is divided into areas of male and female dominion.

A. Koima. This is the western side used primarily by the woman and her children for domestic activities.

1. Father's bed

2. Small room for goats

3. Children's bed

4. Fireplace

5. Mother's bed

6. Gourds are kept here

7. Location of the water pot

8. Entrance door facing north or northeast

9. Mabwaita (the family prayer altar) located on the east side of hut.

B. Njoor. The eastern side is masculine and used for an overnight haven for sheep and goats, a place for the men to drink their beer and a place for the marriage ceremony.

Arrow Points

Each arrow point is fashioned for a utilitarian purpose.

A. The lionet is used for piercing the jugular vein of cattle to obtain blood to drink. It penetrated no deeper than the leather sinews.

B. The kibitinet is used in tribal warfare.

C. The savage-looking kipchabet is used for killing animals and sometimes enemies.

D. The koisit, a lightweight wood point, is used to hunt birds.

The Bridge of Life

"To live a life through is not like crossing a field."

—Russian proverb

How to separate all that green? That was the main challenge when painting **The Bridge of Life** *(facing page). Green grass and a dark, green forest reflected more green into the Nyangoris River. The African and his burro and the metal roof of the gristmill were the only relief in this monochromatic sketch. The nuances of color had to be separated so I began my sketch with pen and ink. It was only a simple matter to finally apply washes of varying shades and values.*

ON THE BANKS OF THE NYANGORIS RIVER

The cattle are dipped each fortnight to prevent an infestation of ticks. Chairman Douglas of the **harambee**—*a farm cooperative—sits on the side of the hill recording the number of cattle dipped. He assesses a ten-shilling fee per head of cattle.*

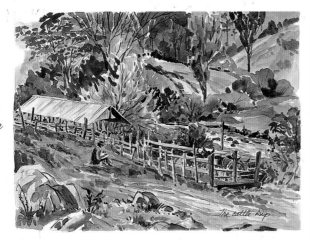

The cattle Dip

JOURNAL NOTE

A Dangerous Crossing

The footbridge of loose timber over the Nyangoris River symbolizes the dangers people face in Kenya. If you walk too close to the edge when crossing this bridge, you may be catapulted into the river. Should you take the center path, you are apt to fall through one of the many holes.

Life, like this bridge, presents many risks. But in Kenya, the chance of negotiating these hazards and living a long life is remote. The holes in the bridge of life are stillbirth, pneumonia, cancer, heart failure, meningitis and malaria. Life expectancy is twenty years less than in the United States. It has been estimated that there is one doctor per 55,000 in these rural areas. Dentists are even scarcer.

I sat on the hillside above the gristmill and began to sketch. When the children spotted me, they stopped their work at the mill and scrambled up the steep hill to see what I was doing. My equipment especially fascinated the little boys: the collapsible water cup, paint box and automatic lead pencil. I completed the painting as the light was fading and the evening chill began to settle in. The children had stayed with me until the bitter end. About this time their father yelled at them for neglecting their chores and they quickly scampered back to the mill. I felt a sense of satisfaction, having enjoyed the afternoon of painting in the company of my young African friends.

What could be appreciated more than receiving an original watercolor painting in the mail? I usually carry a 4" x 6" (10cm x 15cm) block of watercolor paper in my pack for just this purpose. If you don't have a watercolor block, you can use pages of high-quality watercolor paper from a sketchbook. Simply separate the page from the wire binding with scissors or a sharp knife. Turn the picture over and draw a heavy black line to separate the message from the address, paint, stamp and mail. To my amazement, all of my cards have arrived in excellent condition. Here are a few cards that I mailed to my wife and family with snippets of the messages they carried.

Dearest Marlene,
 This is a pretty poor picture but it is late at night. Please hurry home with the geese to join this sad honker.

 Love, Dick

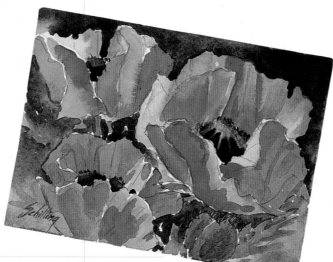

Dear Jennie,
 I saw these flowers today and thought of you.

 Love, Dad

To my granddaughters, Rhianna and Chelsea,
 We went to the Palace of Versailles today. This is where the peace treaty of WWI was signed. The building has over a thousand rooms. Hey girls, how'd you like to clean this house every Saturday morning?

 Love, Grandpa

RUE ST. MARTIN

7 MAY 1995

"He gives strength to the weary"

Isaiah 40:6

Dearest Marlene,
 I wished you could see the blooming of your red tulips. This is one of the prettiest springs ever. Wish you were home. Miss you greatly.

Love, Dick

To my granddaughters, Sarah and Katie,
 I painted this picture of an arch about a block from our hotel. Gram said I painted the colors all wrong because I am color-blind. Well, you get the idea anyway.

Love you, Gramps & Gram

Loons of Isle Royale

FAITHFULNESS

Dearest Marlene,
 This morning I thanked God for your faithfulness. He will lift you up and strengthen you. Tell the children how much I love them and that I miss taking them on long, scouting walks.

Love, Dick

When I works, I works hard;
When I sits I sits loose;
When I thinks,
I falls asleep

Dearest Marlene,
 I am taking good care of the house. I only have to make one-half of the bed each morning. I discovered the leaf blower did a fast job of dusting the furniture and nic-nacs.

Love, Dick

Nature and Animals

The minutiae and intricacies of our natural world never cease to amaze me. All creatures large and small are subjects for study and sketching. I have learned new wonders of entomology by collecting and drawing strange-looking bugs and researching them later.

I have marvelled over the anatomical detail and delicate colors of a fallen bird that I have used as a specimen to paint.

My fascination with the natural sciences probably started during a university course in microbiology. The microscopic studies of normal and abnormal cellular life drawn in my lab notebook taught me an important principle—to draw is to learn.

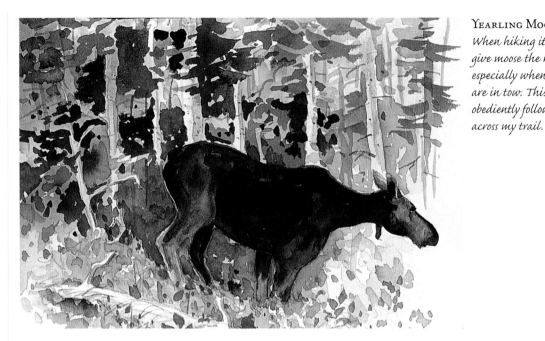

YEARLING MOOSE
When hiking it is wise to give moose the right-of-way, especially when young ones are in tow. This yearling obediently followed her mother across my trail.

A FINE KETTLE OF FISH—TOMORROW'S DINNER
Fisherman from the village of Nunligran, Russia brought a fresh catch of fish into the kitchen of the orphanage. I was a bit of a pest to the cooks who were anxious to clean them for tomorrow's meal. Drawing your meals is a great way to explore wildlife and learn about the anatomy of animals.

THE EMPEROR MOTH AND AN AFRICAN GRASSHOPPER

The moth is a remarkable creature. I discovered little transparent windows within the intricacies of the patterned wings.

The African grasshopper is a very destructive insect. Farmers have hopelessly watched the fruits of their labor quickly disappear as huge swarms of locusts destroyed all vegetation in their fields.

AFRICAN WILDLIFE

Branches of the saptet tree are used in the initiation ceremony of youth into adulthood. Beetles and flys are indoor companions as well.

WOLF SKULL AND BLUEBELLS OF SCOTLAND

Sightings of wolves on Isle Royale are extremely rare. The park biologist loaned me this skull, which I posed among the bluebells. As I was sketching, a mother red fox trotted up the path and paused before me. She tossed me a disgusted glance for impeding her route. As she detoured around me I could see she was carrying a mouse to her kits that must have been hidden nearby.

Missing first bug

Tooth-necked longhorn beetle

Dung beetle or tumblebug

Poetic License

Behold how the beautiful language of poetry, music and painting touches the human spirit. They are finest when encountered together. In my studio, music is the sweet elixir of creativity. I cannot work well without it.

Like a painter before a canvas, the poet uses his craft of words to brush sweeping landscapes. At other times, a finer brush is chosen to express and expose emotions that link our consciousness.

A Poetic Healing

In 1993 Magdalena Jaszczak was a young, volunteer doctor at Tenwek Hospital. Six months before she arrived in Kenya her physician-husband died suddenly. She was exhausted by the pressures and the frenetic pace found in emergency rooms of large, city hospitals at home. She traveled to Tenwek to apply her gift of healing to others and to come to grips with her own personal grief.

Magalena possessed invaluable medical skills and experience that a mission hospital needed. And so it was, on her first day at Tenwek Hospital, Magalena was quickly called to administer general anesthesia for a surgical patient. Her unsuspecting heart was not prepared for what she found. The operating team of loving and caring people paused for prayer and asked for guidance. Upon returning to her empty room late that night, she wrote these words:

My friends / your gratitude overwhelms / my unsuspecting heart / We gather together / to rejoice in prayers / As we saw and cut / Tear and tug / On my sleeping / Patients' heart / And so we treat / The body aches / And even fix / The broken bones / And as we fight / These worldly mishaps / Softly through us / Jesus speaks / And the spirit / Of his love / Truly heals.

—Magdalena E. Jaszczak, M.D.

Dr. Harold Kelch, Surgeon and Obstetrician

"At Tenwek"

My surgeons
My friends
Your gratitude overwhelms
My unsuspecting heart
We gather together
To rejoice in prayers
As we saw and cut
Tear and tug
On my sleeping
Patient's heart
And so we treat
The body aches
And even fix
The broken bones
And as we fight
These worldly mishaps
Softly through us
Jesus speaks
And the spirit
Of His love
Truly heals.

Dr. Magdalena E. Jaszczak Nov 1993

I once saw a face
Of a Kipsigis woman
Weather beaten
By the sun
Tears of sadness
Softly glistening
In her big brown eyes
For many miles
She has traveled
Barefoot in the sand
Since she left
Her father's land
With a tiny baby
Dressed in Kanga
Clinging to her back
And as she came up
Kindly greeting me
Speaking Kipsigis
I saw the ray of hope
Flicker in her eyes
When she explained to me.
That her baby
Has been sick

With a very strange disease
The medicine man
And the tribal herbs
Have not been of help
And now she needed me
At Tenwek

Magdalena E. Jaszczak, M.D.
November 1993

"The Kipsigis Woman"

The Blind Woman

Occasionally the "eye people" would do their vision screening in the back part of my dental clinic. One day a young, blind Kipsigis mother and her angelic child sat down in a chair near me. I seized the moment and reached for my camera. The bright flash from the camera scarcely caused a response from the young woman. I wondered how this mother, without sight, would cope as she raised her children in a dangerous and hostile world. Magdalena Jaszczak added these lines to my picture.

Weather beaten / By the sun / Tears of sadness / Softly glistening / In her big brown eyes / For many miles / She has traveled / Barefoot in the sand / Since she left / Her father's land / With a tiny baby / Dressed in Kanga / Clinging to her back / And as she came up / Kindly greeting me / Speaking Kipsigis / I saw the ray of hope / Flicker in her eyes / When she explained to me / That her baby / Has been sick / And the tribal herbs / Have not been of help / And now she needed me / At Tenwek

—Magdalena E. Jaszczak, M.D.

Paintings From the Ends of the Earth

The blades of the aged, Russian helicopter slowly cranked to a stop, just long enough for me to disembark with my supplies at a remote whaling village in the Siberian Arctic. I went there to provide dental treatment for the children who were left at the orphanage for safekeeping by their parents, the Chukchi reindeer herders.

I thought that I was going to have plenty of time for painting outdoors after my work was done, for this was the time of the white nights of Siberian summer. For several weeks rain and sleet pelted the village. I was unable to explore my surroundings because of driving winds and standing water. Painting outdoors was out of the question.

After treating all of the villagers, I packed my bags in readiness for the return of the Russians. Day after day I listened in vain for the sound of a helicopter. I knew the weather was bad for flying, but had I been forgotten?

I set out painting in earnest to pass the time and to fight off feelings of discouragement. I searched the empty rooms of my barracks for windows that might provide a view of the village. They were all caked with grime and streaked with rivulets of rainwater. The sights were not pretty, yet I knew as an artist I should record what I saw and felt.

The following pictures are a few of the things that I observed from the smudged windows. By the way, just as my food supply had dwindled to pretzels and peanut butter, the helicopter miraculously returned to snatch me from my icy confines.

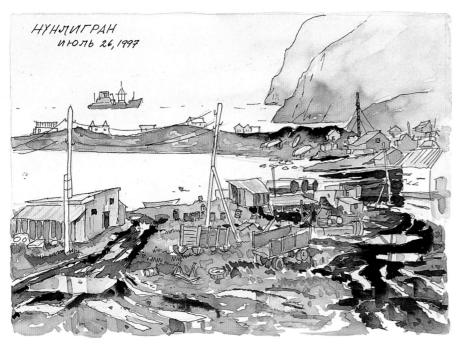

Record What You See
A view of the sea from the village of Nunligran. Roads within the village are covered with coal dust. Behind each building are abandoned oil drums leaking toxic substances that pursue a meandering course to the water supply used by some of the households.

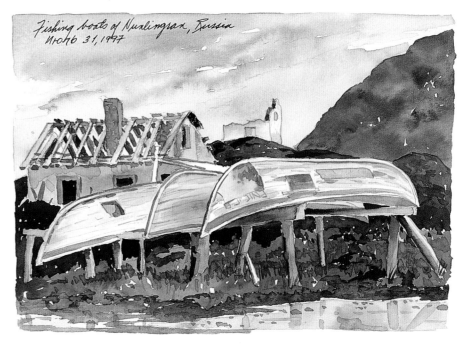

The New Economy
Whaling boats are used to pursue the wounded animals once they are harpooned. In the new, free economy, Chukchis must relearn their hunting and fishing skills to survive.

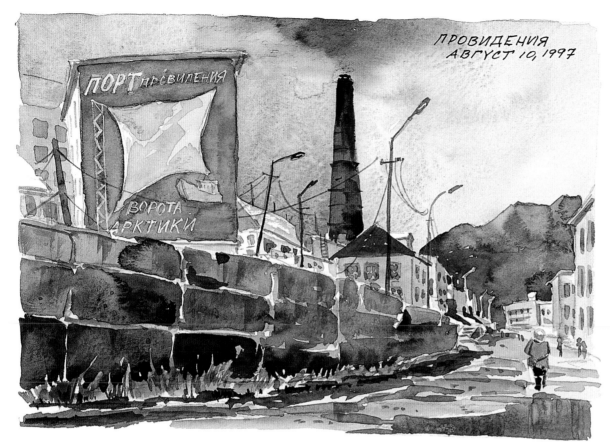

ПРОВИДЕНИЯ
АВГУСТ 10, 1997

ПОРТ провидения

ВОРОТА АРКТИКИ

A Little Night Music
People in this forgotten part of the world have few luxuries, although they hold dearly to their love of flowers, music and art. As a foreigner, I was a special guest at a performance of music and dance at the Cultural House of Provideniya, Russia.

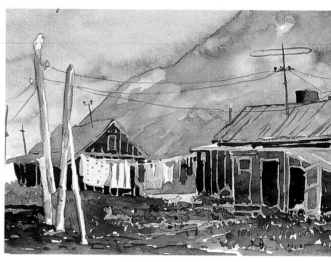

Harsh Temperatures
I watched the woman next door hang out her laundry on this drizzly day. Finally, after a week she gathered it in, no drier than the first day. The whalers' homes are insulated and covered with tarpaper. They must be quite dark inside, for they have few windows in order to guard against the frigid outdoor temperatures.

Capturing a Clear Day
When I look out the window toward the sea, I usually see fog and sleet. Today it partially cleared for a couple of hours, revealing a rather nice beach. The boats are gone now and the men of the village are out fighting heavy seas in search of whales and walrus. I am grateful for my tiny but warm sleeping room.

117

\mathcal{T}he Root Cause

With courage and inquisitive minds, brave explorers and adventurers have pushed back frontiers and expanded our knowledge of new lands and natural sciences. Meriwether Lewis, John Muir, Thomas Moran and John Wesley Powell were men of a new generation who gazed on wondrous sights and recorded their findings in diaries and sketchbooks. It was a world without digital and video cameras; perhaps this was to their benefit, for what is drawn is learned. Their pictures and impressions are a rich heritage for those of us who aspire to be traveling artists.

Diane M. Bolz of **The Smithsonian Magazine** has said, "... art is one of the most effective means of communicating new information about the natural sciences." In an attempt to walk in the boots of early artist-explorers, I carry a sketchbook and small pan of watercolors as my ever-present traveling companions. I am always prepared to capture that unique image or magic moment.

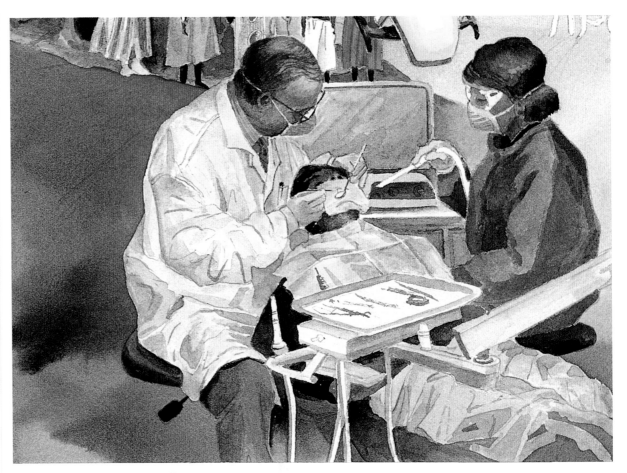

SELF-PORTRAIT: THE ARTISTIC DENTIST
This painting is a self-portrait demonstrating my other profession, dentistry, at the Pine Ridge Indian Reservation. I consider myself very fortunate to be able to use my dentistry skills to enhance my opportunities for painting. As a volunteer dentist I have travelled the world and been greeted by some wonderful people and scenery.

Asia

Chukotka

Migration route

Cordilleran ice sheet

North America

Lower first molars

Trifurcated root

Normal bifurcated root

Pine Ridge Indian Reservation

JOURNAL NOTE

Bridging Cultures

In 1995 I worked as a volunteer dentist to the Lakota Sioux Indians of the Pine Ridge Reservation in South Dakota. My patients had strange-sounding names, like Red Cedar Face, Broken Leg and Has No Horse. At times, as I was extracting their broken and infected teeth, I noticed a reoccurring phenomena. The extracted lower, first molars of some of the Native Americans had three distinct roots. I had extracted thousands of two-rooted lower molars, but I had never seen a three-rooted first molar.

On the other side of the Arctic Ocean I worked in the Chukotka Region of the Siberian Arctic. Dental care in this cold but strangely beautiful land was nonexistent in 1996. My patients were Chukchi people of Asian decent and Eskimos of Yupik ancestry. What I found startled me—many of these indigenous people had the same three-rooted lower first molars I first noticed in South Dakota.

I believe I was seeing the fingerprint of the ancestral migration of Asian people across the Bering landbridge to what is now North America. Fourteen thousand years ago, waves of immigrant people began crossing the landbridge and traversed melting sheets of the Cordilleran ice to become the first occupants of the Americas. This unique tooth anomaly appears to link Native Americans with these ancient people of Asia. Emigrating peoples from Europe, on the other hand, brought with them the dominant two-rooted molar.

The Panama Canal: A Visual Journey

Recording a specific trip can be exciting and a great record of your experience. I have traveled through the Panama Canal twice in my journeys. Along with the record of my journey, I researched the history of the canal and how it was constructed. This historical information gave me a greater affinity for the Canal and enhanced my painting. Research what you are painting; the more you know about your subject, the better able you will be to paint it.

Costa Rica Caribbean Sea Panama Canal Colón

Panama Pacific Ocean Balboa

MAP OF CENTRAL AMERICA
I always thought the Canal crossed Panama in a horizontal, east-west fashion. To my surprise we enter the Pacific portal further east than the Atlantic entrance. This means that we will travel in a northwesterly direction to reach the Caribbean Sea. Another enigma — the sun will rise on my ship before rising on the Atlantic side of the Canal.

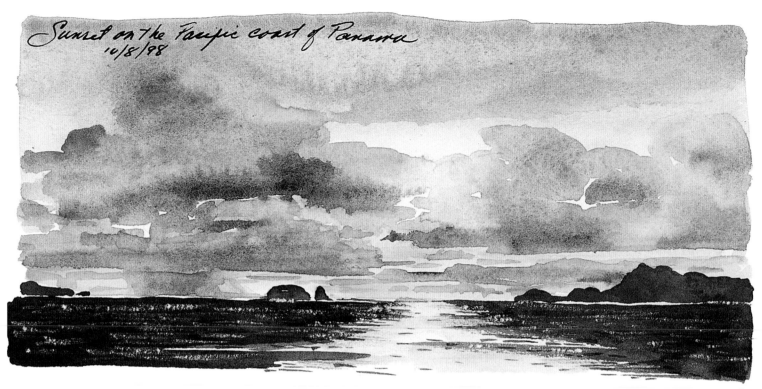

Sunset on the Pacific coast of Panama
10/8/98

I watched the sun set over the Pacific from the slumbering **M.S. Ryndam**. *The ship would enter the canal at Balboa early the next morning. The journey to traverse the fifty-mile canal will take eight to ten hours.*

SINGLE FILE
Boats line up in the Pacific Ocean and patiently await their turn to pass through the canal.

JOURNAL NOTE

The Panama Canal—A History
John F. Stevens' plan was to construct a canal using a system of locks and electric locomotives to guide ships in transit. The Panama isthmus was the chosen location—taking precedent over the alternative site through the less geologically stable country of Nicaraugua.

The Canal consists of three sets of locks, two lakes and a gorge through the Continental Divide. It is approximately fifty miles long, running from northwest to southeast. Amazingly, the canal traverses the Continental Divide. Work was started in 1904 and completed in 1914 at a cost of $352 million and the lives of 5,000 workers. On December 31, 1999, ownership of the Canal was transferred to the country of Panama.

Through the Canal: Setting Your Course

The construction of the Panama Canal was one of the greatest engineering achievements of all time, conquering almost insurmountable challenges. The visionaries faced three main problems—the logistical organization of the project, untested engineering design and public health safety.

Planning the pages of your sketchbook is not quite as difficult as building a canal, but at times may seem as daunting. Don't be afraid to plan more difficult layouts in your sketchbook. These two pages contain a lot of information that works well together. A well-composed page creates interest and is fun to paint. When planning your journal, consider how you want your pages to look.

JOURNEY THROUGH THE CANAL

Follow the images on these pages as we journey through the Panama Canal. Near the center of the canal system is the Gaillard Cut. Engineers and workers sliced through the Continental Divide at this point and excavated it to a depth of forty-five feet creating a passageway between the two lakes.

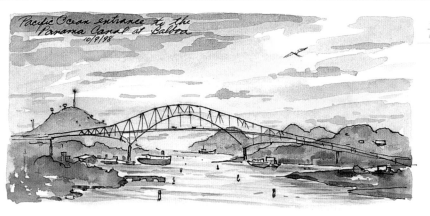

Pacific Ocean entrance to the Panama Canal at Balboa 10/9/98

#1 PREPARING FOR TRAVEL
Before entering the Pacific Ocean portal at Balboa, the **Ryndam** passes under the Bridge of the Americas that connects the two continents.

This simple horizontal sketch was done from the ship's stern. I quickly learned that I had more time to paint my subject from the rear of the ship rather than in the bow, where the scene quickly passed me.

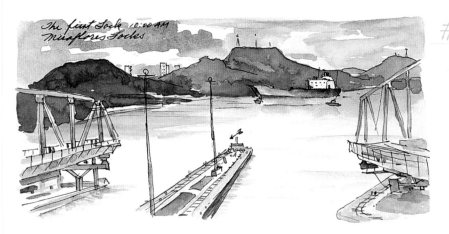

The first lock 10:00 AM Miraflores locks

#2 BEGINNING THE JOURNEY
The gates close and lock, separating us from the Pacific Ocean as water flows into the lock. The ship is lifted fifty-six feet above the sea to the level of Miraflores Lake.

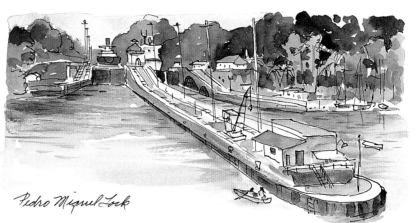

Pedro Miguel Lock

#3 THROUGH THE LOCKS
The Pedro Miguel locks are the second in the series of three locks. It was constructed three miles inland from the Pacific and lifts our ship to the next level of Gatun Lake.

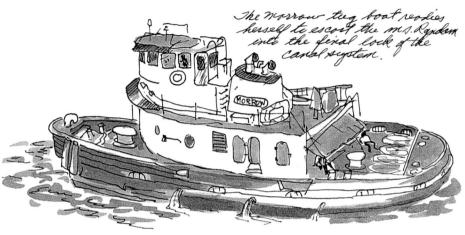

The Morrow tug boat readies herself to escort the m.s. Ryndam into the final lock of the canal system.

#4 MULES DO MOST OF THE WORK
Electric-powered engines guide our ship through the locks. They are affectionately known as mules, named after the animals that pulled boats through previous canals in Europe and America.

#5 TUGBOATS ASSIST OUR JOURNEY
*The **Morrow** moves up and nudges the **Ryndam** into position for entering the final series of canal locks.*

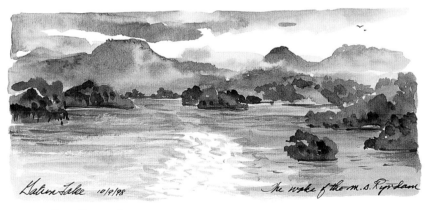

Gatun Lake 10/9/98

The wake of the m.s. Ryndam

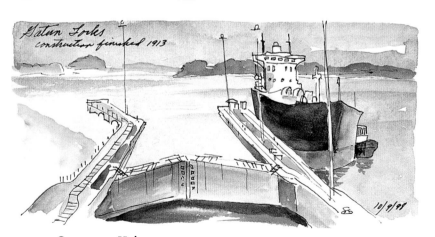

Gatun Locks construction finished 1913

10/9/98

#6 FULL SPEED AHEAD
This is a man-made lake surrounded by jungle and created by damming the Chagres River. Above, a second lake helps fill and control the level of Gatun. We are on our downhill journey to the Caribbean.

#7 CARIBBEAN HO!
Fresh water from the lake floods the lock chambers of Gatun. The locks are 1000 feet long (304 meters) and 110 feet (33.4 meters) wide. In a series of two steps, water is released, lowering our ship level with the Caribbean Sea.

Saying Goodbye

My watercolor journeys have led me to the white, limestone causeways to the Mayan pyramids in the rain forests of Tikal and to the marble streets of Ephesus, Turkey, where Saint Paul once trod. Still, my home in Colorado nurtures and restores my spirit. It is here that there are many discoveries yet to be made, and not so far away.

When I do leave home, I like to travel with a purpose. Investing myself in the lives of others only enhances the joy and the experience. I have sat alone on a roadside in a distant country painting when encountered by a curious sojourner. He stops to compliment my painting efforts... I, in turn, admire his homeland. We meet as strangers but part as friends.

Painting in public opens doors of understanding. If one prefers to be left alone, it may be best to read a book, for the reader will never be disturbed. But should an artist paint a picture, a friendly chat will surely follow. This verse has been a favorite of mine:

The world stands out on either side / No wider than the heart is wide; / Above the world is stretched the sky,— / No higher than the soul is high. / The heart can push the sea and land / Farther away on either hand; / The soul can split the sky in two, / And let the face of God shine through. / But East and West will pinch the heart / That cannot keep them pushed apart; / And he whose soul is flat—the sky / Will cave in on him by and by.

—Edna St. Vincent Millay, *Renascence*, 1912

THE HISTORIC STANLEY HOTEL, ESTES PARK, COLORADO

"Welcome, O life! I go to encounter for the millionth time the reality of experience and to forge in the smithy of my soul the uncreated conscience of my race."

—James Joyce, *A Portrait of the Artist as a Young Man*

Index

Action lines, 38–39
Aerial view, 18
Africa
 Kaboson, 68
 Kenya, 70, 71, 77, 79, 84,
 85, 106, 107
 Maasiland, 104
 map of, 99
 Nyangoris River, 108
 people at work in, 86–87
 scenes of, 20
 Tanzania, 91, 93, 105
 Tenuek, 114
 wildlife in, 113
African grasshopper, 113
African scarf, 61
Alaska
 Anchorage, 25, 68
 Juneau, 15, 19, 20, 89
 Ketchikan, 19, 25, 49
 Sitka, 25, 38
 Valdez, 95
Andes Mountains, 94
Animals, 112–113
Argentina, Buenos Aires, 90
Arrow points, 107
Artistic license, 82–83

Background, 22, 58
Balance, 38
Beach, 83, 117
Beagle Channel, 95
Beetles, 113

Beginning a painting, 22
Biltmore Estate, 16
Boats
 cruise ship, 75
 depicting activity on, 27
 gondolas, 12, 103
 model schooner, 85
 on Panama Canal, 121–123
 ship construction, 17
 ships at sea, 88–89
 shipyard, 104
 whaling, 116
Bridge, 25, 108–109
British Columbia, Victoria, 65
Brushes, 14
Buildings
 architectural patterns, 25
 blocking in shapes of,
 102–103
 implied, 91
 outline of distant, 21
 rooflines, 25
 vignette, 32–33
 windows, 25

California
 Cabo San Lucas, 17
 San Francisco, 29, 89
Calligraphic lines, 45
Canada, Quebec, 33
Caribbean island, 75
Carrying case, 14
Cast shadow, 30–31

Character sketches, 26, 49, 92
Chile
 Cape Horn, 17
 Puerto Montt, 57
 Punte Arenas, 50
Churches, 74
 cathedral, 32, 35
 mosque, 101
 spires and domes, 33
Clouds, 30, 56–57
Colorado, 80–81, 124
Composition, 38–39
Constellation, 98
Costa Rica, Santa Domingo,
 56
Cover of sketchbook, 62–63
Cultures
 bridging, 119
 discovering customs and,
 106
 interacting with other,
 70–71
 recording, 61

Damage control
 gouache, 40
 lifting paint, 40
 lightening, 41
 rainy conditions, 50–51
Dark-value marker, 42–43
Depth, creating, 35, 56–59
Design principles, 38–39

Detail
 eliminating, 91
 impression of, 35
Drawing style, 26

Edges, soft, 52, 97
Elephant, 81, 91
Emotion
 capturing, 52
 shadows and, 30
Emperor moth, 113
Estonia, Tallinn, 22

Finland, Helsinki, 22, 91
Fish, 112
Flowers, 64–65
 arrangements, 65, 85
 bougainvillea, 39
 hibiscus, 65, 84
 implied, 91
 poppies, 66–67
 shopping for, 64
Footbridge, 108–109
Foreground, 22
Form shadow, 30–31, 45
France, Paris, 29
Friendly encounters, 78–79
Fruit still life, 85

Gastineau Channel, 24
Georgia
 Brunswick, 42
 Saint Simon's Island, 88, 101

Germany, Rostock, 33
Glaciers, 94–95
Gouache, 40
Grain elevator, 81
Granary, 44–45
Grasshopper, African, 113
Greece, Piraeus, 89
Guatemala, Tikal, 124

Hawaii, Kilanea, 43
Historic sites, 100–101
Hometown scenes, 80–81
Honduras, 78, 82, 92
Horizontal format, 20–21
Hostile conditions, 74
Houses, 40–43, 68–69, 82–83
Hut, grass, 107

Ice fields, 94–95
Impromptu setting, supplies
 for, 14
Ink washes, 29
Insects, 113
Istanbul, 101
Italy
 Florence, 100
 Lido di Jesolo, 26
 Messina, Sicily, 22, 74
 Rome, 100
 Venice, 12, 17, 21, 34–35,
 64, 102–104

Jerusalem, 33, 49, 101
Jewelry, beaded, 106

Lifting paint, 40, 52
Light, en plein air, 30
Lighthouse, 88
Lights and darks, sequence
 for, 44
Lines, calligraphic, 45
Location, choosing, 18–19
Louvre, 29

Maine, Bar Harbor, 27
Maps, 98–99
 Africa, 99
 Central America, 120
Markers
dark-value, 42–43
watercolor, 28
Mexico
 Acapulco, 90, 92
 market in, 82
 Puerto Vallarta, 92
Michigan, Isle Royale, 26,
 50, 55, 64, 69, 113
Middle ground, 22
Middle values, 44
Mistakes, fixing, 40. **See also**
 Damage control
Monaco, 32, 100
Moose, 26, 55, 112
Mountains
 distant, 56–59
 glaciers, 94–95

Natural disasters, 104
Nature, 112–113
Northern Ireland, Belfast, 51

Objects
 placement of, 26
 rounded, 96–97

Painting survival kit, 15
Paints, high-grade, 14
Panama Canal, 120–123
Paper, 14
Park scenes, 90–91
Pen and ink sketch, 22,
 26–29
Pencil sketch, 26
Pencil with watercolor,
 54–55
People
 blind woman holding
 child, 115
 faces, 60–61, 92–93
 finding models, 92–93
 at work, 86–87
Perspective
downhill, 90
See also Point of view
Photo references, 34, 60
Pine Ridge Indian reserva-
 tion, 118–119
Plants, 64–65, 84. **See also**
 Flowers
Poetic license, 114–115

Point of view, 24–25. **See also**
 View
Portraits, 92–93
Postcards, 110–111
Prince Edward Island, 43, 51

Quebec, 33

Railroad station, 81
Rainy conditions, 19, 50–51
Reflected image, 46–47, 53,
 80
Remarque, 54
Residential scenes, 68–69
Rocks, 96–97
Rounded objects, 96
Russia
 Nunligran, 56, 69, 71, 112,
 116
 Provideniya, 28, 38, 69,
 76, 117

St. Maarten, 83
Scarf, African, 61
Self-portrait, 118
Shadows, 30–31
 cast, 30–31
 form, 30, 45
 value of, 43
Shapes
 building, blocking in,
 102–103
 value of, 43

Shipboard view, 19
Sketch, simple, 16
Sketchbook
 cover of, 62–63
 double-page pictures in,
 36–37
 formats, 20–21
 planning pages of, 122
 title page of, 62–63
Sketchbook journal, 10
Sky
 cloudy, 57
 constellation in, 98
Snow, 94–95
Southern Cross, 98
Spain
 Granada, 48
 Puerto de la Coruna, 16
Sparkle line, 46, 53
Spatial separation, 59
Still life motif, 84
Style, drawing, 26
Supplies, 14–15
Sweden, Stockholm, 36

Ten-minute sketch, 48–49
Title page, 62–63
Trees
 baobab (upside-down), 105
 choruet (friendship), 70
 fig, 105
 frangipani (giggle), 23
 implied, 91

mabwaita (family altar),
 107
 suggesting bark on, 97
Turkey
 Kusadasi, 31, 88

Underpainting, 66
Uruguay, Montevideo, 27

Value sketch, 42, 44–45
Vanishing point, 30
Vegetable still life, 84
Vertical format, 20
View
 aerial, 18
high-angle, 19
 shipboard, 19
See also Point of view
Vignette, 32

Washes, ink, 29
Watery reflection, 46–47, 53,
 80
Watercolor markers, 28. **See
 also** Dark-value marker
Watercolor paper, 14
Wet-in-wet approach, 40
Wood, painting character of,
 72–73

More Great Watercolor Instruction From North Light Books!

Beautifully illustrated and superbly written, this wonderful guide is perfect for watercolorists of all skill levels! Gordon MacKenzie distills over thirty years of teaching experience into dozens of painting tricks and techniques that cover everything from key concepts, such as composition, color and value, to fine details, including washes, masking and more.

ISBN 0-89134-946-4, hardcover, 144 pages, #31443-K

Penny Soto shows you how to add emotion, drama and excitement to your work with color. By following her simple step-by-step instructions, you'll learn how to combine and juxtapose hues to create vibrant paintings. You'll also discover the many personalities of color, plus techniques for capturing light, shadow, and reflections in water.

ISBN 1-58180-215-3, hardcover, 144 pages, #31993-K

Packed with insights, tips and advice, Watercolor Wisdom is a virtual master class in watercolor painting. Jo Taylor illustrates every important technique with examples, sketches and demonstrations, covering everything from brush selection and composition to color mixing and light. You'll learn how to find your personal style, work emotion into your work, understand and create abstract art and more.

ISBN 1-58180-240-4, hardcover, 176 pages, #32018-K

Create your own artist's journal and capture those fleeting moments of inspiration and beauty! Erin O'Toole's friendly, fun-to-read advice makes getting started easy. You'll learn how to observe and record what you see, compose images that come alive with color and movement, and make a travel kit for creating art anywhere, at any time.

ISBN 1-58180-170-X, hardcover, 128 pages, #31921-K

THESE BOOKS AND OTHER FINE ART TITLES ARE AVAILABLE FROM YOUR LOCAL ART & CRAFT RETAILER, BOOKSTORE, ONLINE SUPPLIER OR BY CALLING 1-800-448-0915.